# Jon Schueler

## To the North

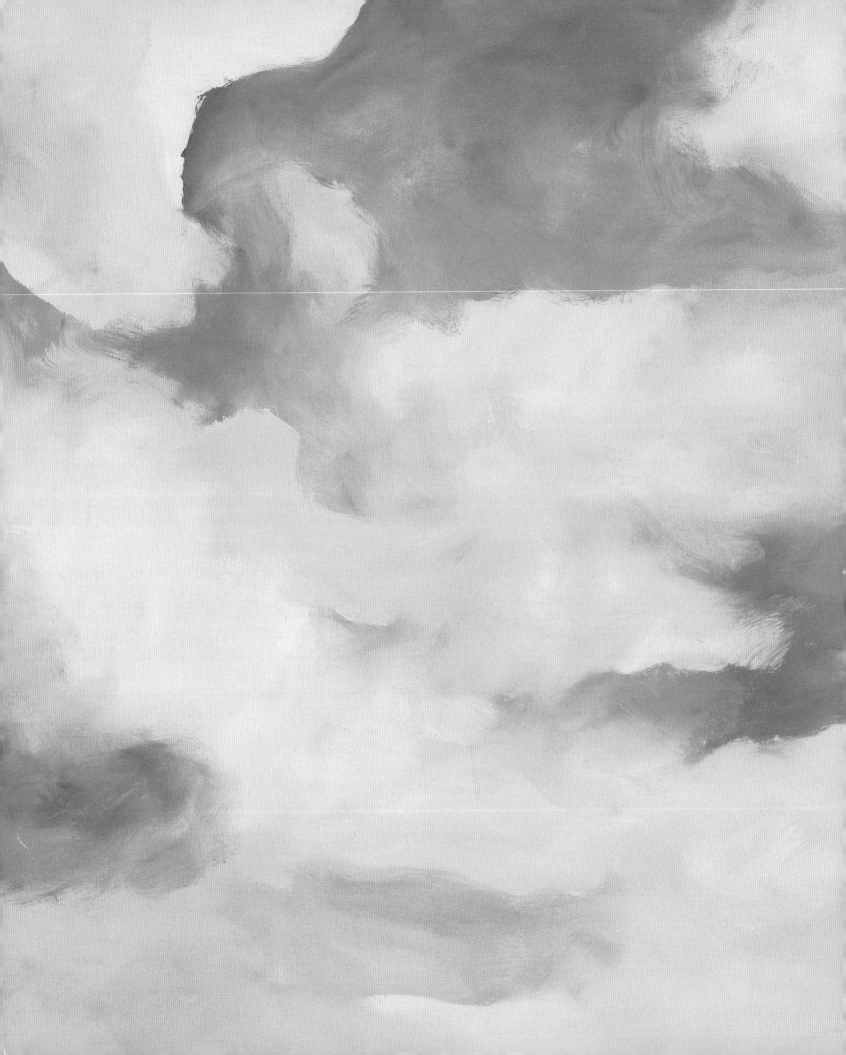

# Jon Schueler

## To the North

Gerald Nordland
Richard Ingleby

MERRELL

**MERRELL**

First published 2002 by
Merrell Publishers Limited
42 Southwark Street
London SEI IUN

TELEPHONE + 44 (0)20 7403 2047
E-MAIL mail@merrellpublishers.com
WEBSITE www.merrellpublishers.com

Distributed in the USA by Rizzoli
International Publications, Inc.
through St Martin's Press,
175 Fifth Avenue, New York,
New York 10010

British Library Cataloguing-in-
Publication Data:
Nordland, Gerald, 1927–
Jon Schueler : to the North
1.Schueler, Jon, 1916–1992 –
Criticism and interpretation
2.Painting – United States
3.Scotland – In art
I.Title II.Ingleby, Richard, 1967–
III.Schueler, Jon
759.1

ISBN 1 85894 177 6

CONSULTANT EDITOR Magda Salvesen
EDITOR Iain Ross
DESIGNER Kate Ward

Printed and bound in Italy

FRONT COVER *The Sound of Sleat:
June Night XIII*, Romasaig, 1970
(pl. 48, detail)

BACK COVER *Night Sky: October II*,
Mallaig, 1970 (pl. 46, detail)

BACK FLAP Jon Schueler in his
studio, New York, 1991

FRONTISPIECE *Blues for Magda*,
New York, 1982 (pl. 78, detail)

PP. 42–43 *Light and Black Shadow*,
Romasaig, 1977 (pl. 67, detail)

The inventory numbers cited in the
captions are those of the Schueler
Estate. Some works from after 1970
also take the inventory number as
their title.

Funded in part by
The Peter and Madeleine
Martin Foundation for the
Creative Arts

# Contents

# Jon Schueler

## American Painter

**by Gerald Nordland**

Jon Schueler was born on 12 September 1916 in Milwaukee, Wisconsin, to a middle-class family. His mother died when he was six months old, and his father, George, a dealer in automotive tyres, remarried in 1920; a son, Robert, and a daughter, Paula, were born in 1922 and 1926 respectively. Jon bonded with his stepmother, but after learning about his true mother in his pre-teen years, he was haunted by a recurring sense of guilt at having 'forgotten' her. He attended public schools, with an interlude in a private school just prior to the crash of 1929 and the ensuing Depression. His early interest in music – he played the piano and formed a band while in high school – prefigured the importance that jazz would play later in his life.

Assuming that he would follow in his father's business, his parents advised him to study economics at the University of Wisconsin, Madison, where he received his BA in 1938. Part-time and summer jobs during his college years, however, led him to question whether he was suited to a business career. A senior-year romance emboldened him to consider writing as an alternative, with teaching literature as a fall-back plan. Both parents were dismayed by this prospect, and harsh words were exchanged. Jon turned to his maternal grandparents, Rudolf and Emma Haase, for help, and discovered that they had provided for such needs ten years earlier by placing a bond for him in his parents' custody. Although demanding the money only deepened the breach with his parents, it enabled him to go to graduate school. Two years reading English literature left him with an enduring joy in poetry and a definite inclination towards writing. He received his MA from Madison in June 1940, with the intent of later pursuing a doctorate at Yale.

In 1940–41 Schueler worked in a Chicago department store, tried out as a junior newspaper reporter on the *New Haven Register* and attended a session at Bread Loaf School of English in Vermont. The

**Fig. 1**
Jon Schueler
**Evening I**
(pl. 18, detail)

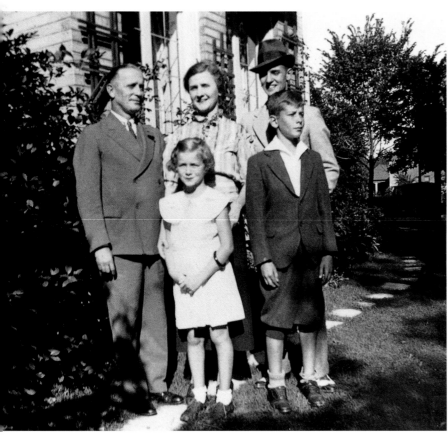 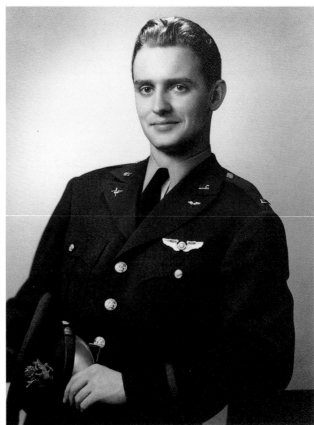

**Fig. 2**
Jon Schueler
(rear right) with his
father, stepmother,
sister Paula and
brother Bob,
*c.* 1933, in
Milwaukee

**Fig. 3**
Jon Schueler,
1942, before
leaving for Britain
in the US Army
Air Force

disturbing news during these years – of German and Italian military conquests, the Fall of France and the Battle of Britain – led to his decision in September 1941, even before America had entered the war, to enlist in the US Army Air Force. After a rigorous training at various bases around the US, he was commissioned as a navigator of B-17 Flying Fortresses. In August 1942, after a brief courtship, he married Jane Elton, just before his unit was sent to Britain for missions over France and Germany. A few months later, while in London at a tea dance, he met and soon became intimate with Bunty Challis, a British volunteer in the American Ambulance Corps. Her vivid descriptions of summers in the Scottish Highlands merged with his memories of storms on Lake Superior and flight experiences of lightning, auroras and mirages to create images so powerful that they stayed with him until he finally visited Scotland in 1957 and confirmed her reports. In 1944 Schueler was discharged for medical reasons relating to battle fatigue, but retained stark memories of aerial observation, combat and lost comrades.

Following his hospitalization and discharge, Jon and Jane Schueler relocated to Los Angeles, where their children, Jamie and Joya, were born in 1944 and 1946. He had received an inheritance from his Grandfather Haase while in service, and with that financial cushion he felt able to enter into a variety of projects as he faced civilian life. He planned and began a war-service memoir, projected a novel, wrote articles for magazines, worked as a radio announcer and built a house in Topanga Canyon. He invested money and physical energy in establishing a jazz club in the San Fernando Valley, which was to feature the jazz singer Anita O'Day. Then, on the spur of the moment, when Jane enrolled in a portraiture class with David Lax, Jon decided to join her. He showed no special talent, but his enthusiasm received encouragement from Lax. In the meantime, he applied for a position

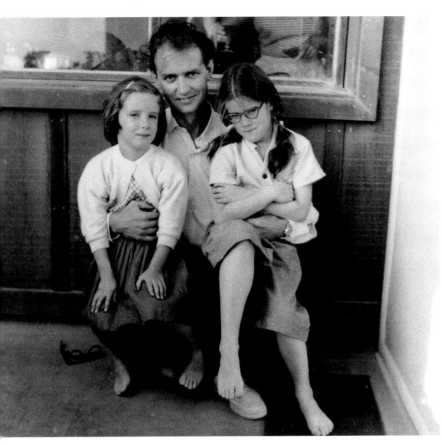

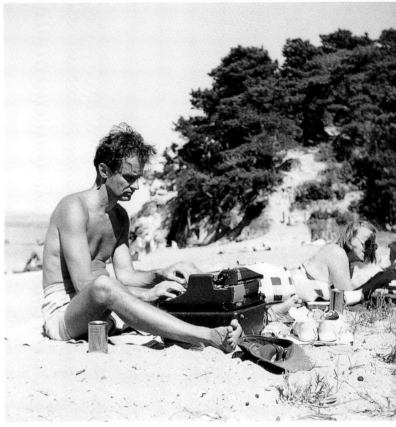

teaching English literature, and in 1947 was hired by the University of San Francisco (USF; a Jesuit school). Once settled, he became aware of the California School of Fine Arts (CSFA) – then the Bay Area's most distinguished art school – and began attending classes part-time. After two years his teaching contract at USF was not renewed owing to his separation from Jane and the plans for a divorce.

Schueler became a full-time student in the CSFA day programme in early 1949, and continued until June of 1951, with GI Bill assistance. The school was small, with an able and serious staff of instructors. Students benefited from 'bull sessions' with advanced classmates, a mature lot, older by three to five years than the usual college student. These exchanges touched on subjects ranging from primitive art to mythology, from the religious roots of art to personal ideals and deeply felt experiences. The registrar's enrolment list of those years reveals a strong list of artists who would gain recognition in the future.[1] The CSFA had been moribund for some years, with a competent but uninspired faculty and a debutante enrolment. This changed when Douglas MacAgy, a San Francisco Museum of Art (SFMA) curator, was appointed director in June 1945, with authority to hire a new faculty of energetic and dedicated artists that ultimately included Ansel Adams, Elmer Bischoff, Dorr Bothwell, Edward Corbett, Richard Diebenkorn, Stanley Hayter, Hassel Smith, Clay Spohn and Clyfford Still, joining the veteran David Park.

The CSFA instructors were not trained teachers but practising artists with minimal teaching skills who taught for modest salaries. They followed the example of their own teachers and drew upon personal discoveries. Clyfford Still was for many the most influential figure within the faculty, and MacAgy accepted his recommendations in bringing the New Yorkers Ad Reinhardt and Mark Rothko for summer sessions. In January 1946 there was only a handful of GIs registered, and only

**Fig. 4**
Jon Schueler with his children, Joya (left) and Jamie, California, 1953

**Fig. 5**
Jon Schueler writing while visiting his children in California, 1953

one of them painted abstractly. Eighteen months later the student body was predominantly composed of GIs, and everyone seemed to be working on large abstract canvases. Faculty members had varied backgrounds and a range of achievements, and Schueler responded to their idiosyncrasies. "Anything could, and was meant to happen there [at CSFA]." The intellectual and emotional mark of the school was "a slightly hysterical atmosphere in which students and teachers, as MacAgy put it, knew they were making history".[2]

He studied with seven instructors, often repeatedly – David Park (five terms), Hassel Smith (three terms), Elmer Bischoff (three terms) and Clyfford Still (three terms). Clyfford Still made a major impression on Schueler and became his mentor, advocating discipline, self-control, and the assumption of total responsibility for one's work and its display. The strong impression that Still made on Schueler is clear from his recollections:

I remember the first course I ever took with Still. I'm sure he hated teaching this god-damned course. It was just a buck to him. So here we all were sitting in this little room at some tables with chairs and he said, "the title of this course is Space Organization, so organize space," and that's the last he ever said about space organization during the entire semester. But it was a terribly profound thing. It really was.

He did a lot of talking about all sorts of things. One of the things that he certainly was saying over and over again in a million different ways and which has become an essential part of my thinking is the idea that the artist is nothing unless he accepts the total responsibility for everything that he does. It is by making a responsible move that he makes a statement.[3]

Art was seen as a holy grail for that generation, entailing a search that would almost inevitably preclude financial success. A number of CSFA instructors expressed the view that they were all artists together, the faculty members being simply a few years older and more experienced than the students. Elmer Bischoff referred to the relationship as a "brotherhood".[4] Most of the faculty was then working in a painterly, abstract fashion, including Park, Bischoff, Corbett and Diebenkorn. Only when a faculty member exhibited at San Francisco Museum of Art or the Legion of Honor (as did Rothko, Still, Bischoff and Diebenkorn) could students gather a comprehensive idea of an instructor's work. In drawing classes instructors demonstrated, corrected or clarified student work, and gave talks, illustrated by slides, communicating their individual views. Diebenkorn showed respect for Matisse, then generally disdained by the faculty, while Still brought a portfolio of images by J.M.W. Turner to class, discussed the work and pinned some up for examination. Very rarely, Clyfford Still would invite an individual (as he did Richard Diebenkorn) to his studio at the base of the CSFA tower, and once he took Schueler as one of a group of three students. Schueler responded viscerally: "He had hung four huge paintings, one on each of the walls. I had never seen anything like them before. Powerful images. Blood reds, scarred browns, and blacks. A flash of color. Bumps and scourges, tensely violent, like the surface of life. I didn't know if I liked them. I was breathless with the experience."[5]

Still advocated a new way of thinking about the painted image as a visual equivalent of the sublime in oneself. He did not want students to paint as he did, nor did he specifically recommend abstract painting. He asked students to make something they had not seen before, and to affirm a positive expression of themselves. He advised against exhibiting in group or competitive shows, but favoured solo exhibitions or those where artists were represented by multiple works. Observers, he believed,

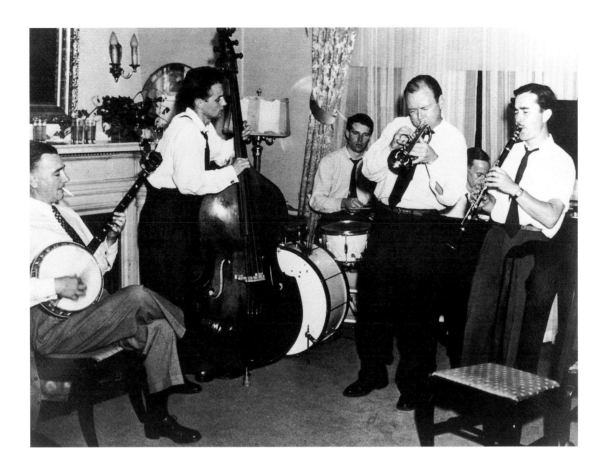

**Fig. 6**
Jon Schueler on
double bass with
the Studio 13
Jazz Band of the
California School
of Fine Arts, San
Francisco, late 1950

Roland Howser,
banjo; Jack Lowe,
drums; Elmer
Bischoff, trumpet;
David Park, piano;
Charles Clark,
clarinet

could not accept or understand a new vision through a single work. He urged students to "avoid playing the museum's game", or becoming involved with dealers whose only interest in their work was financial.

Inspired by his teaching, twelve of Still's students founded Metart Gallery, which was conceived as a partnership permitting each partner (later twenty-four) to have full control of the facility during the month that he was exhibiting his work.[6] Metart required a monthly rent contribution and duty hours when it was open. Located in a storefront, at 527 Bush Street, it opened in April 1949 with an Ernest Briggs show. Not all members held shows there, as the gallery closed in July 1950.

An important feature of extra-curricular life at CSFA was the Studio 13 Jazz Band, composed of students and faculty members, which played for special events and "raucous dances". Park played piano; Bischoff, trumpet; Charles Clark or Bill Napier, clarinet; Bob Mielke, trombone; with MacAgy and Jack Lowe, among others, on drums. Schueler now had a serious interest in jazz, played the piano, and received guidance from his friend, the virtuoso Oscar Pettiford, concerning the double bass. Jon believed that he brought the inventiveness he had found in jazz to his painting. In jazz you listen for patterns and chord changes, and respond intuitively, instantly to the playing of your bandmates. The impromptu character of collective improvisation on traditional tunes and chord structures seemed directly relevant to the students and faculty, and was reinforced by the New Orleans Revival and the appearance in local venues of ensembles led by Bunk Johnson, Kid Ory and Lu Watters' Yerba Buena Jazz Band. As Elmer Bischoff said: "Jazz was a part of the spirit of the time."[7]

In his first year at CSFA Schueler painted a number of portraits, descriptive cityscapes, landscapes and views of Fisherman's Wharf, related to Smith's landscape class. His *Memory of Love* (1949; pl. 1)

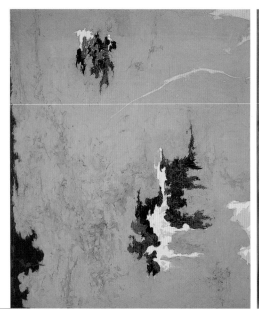
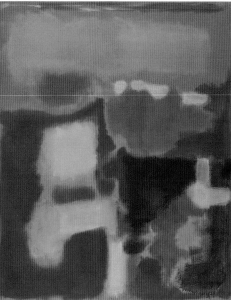
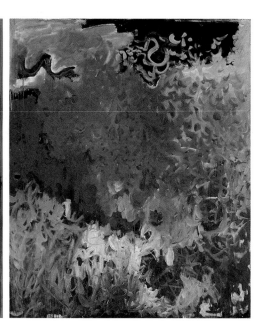

**Fig. 7**
Clyfford Still
**1948-C**

1948
Oil on canvas
205 x 175 cm
(80⅞ x 68¾ in.)

**Fig. 8**
Mark Rothko
**No. 1**
**(No. 18, 1948)**

1948–49
Oil on canvas
173 x 142 cm
(67¾ x 55⅞ in.)

**Fig. 9**
Hassel Smith
**The Little Big Horn**

1953
Oil on canvas
216 x 178 cm
(85 x 70 in.)

was completed in October while he was in Still's space organization class. He was then in his third term and had also studied drawing and painting with Bischoff, Park and Diebenkorn. The painting is dark, developed in black, grey and umber on a ground of browns, with accents of yellow and red. It can be recognized as a work of early biomorphic Abstract Expressionism from San Francisco, yet it appears independent of his instructors' influence.

Schueler held his first solo show in 1950 at Metart Gallery, in which he exhibited a number of large paintings, including oils on paper. With *Toward Morning I* (1950; pl. 3) he was beginning to integrate his experiences of the previous eighteen months. The title suggests that the red at the upper edge is the rising sun. The canvas is otherwise very dark, with radiations of red pigment. There is no slathering of material, no vertical knife and brushwork (as seen in Still's paintings [fig. 7]). This canvas is conceived in the manner of a Rothko or a Still, but effected with a searching, distinctive touch. In the summer of 1949 Rothko had taught at CSFA, but Schueler had not enrolled in his class. Although he made frequent references to Rothko in *The Sound of Sleat* manuscript,[8] the text reflects a distrust and wariness of the older painter. Nonetheless, *Untitled I* (1950; pl. 4) feels closer to Rothko's *multiforms* (1947–48; fig. 8) than to anything in Still's œuvre. The lower two-thirds of the ground is dark with patches of black, various greys and red shadows. The upper third establishes areas of yellow and red, which relate to the colours in the dark field through a suggestion of circular movement. *Toward Morning III* (99 × 122 cm/38 × 48 in.) was painted in spring 1951 and is darker than *Toward Morning I*. Reds shine through the ground in the upper half of the canvas, particularly at the upper edge. Schueler seems to suggest the idea of night penetrated by the power of the sun. Other works of the period show expressionist handling of the paint and stronger contrasts, and there

# North

## Jon Schueler in Scotland

**by Richard Ingleby**

Jon Schueler's first visit to Scotland lasted just a few hours, after his B-17 bomber touched down at Prestwick in Ayrshire following a terrifying flight through the night, "between layers of storm clouds" and "tossed all over the sky".[1] It was November 1942 and Schueler, a newly trained navigator in the US Army Air Force, 303rd Bomber Group, was coming to join the war in Europe, en route from Newfoundland to RAF Molesworth in England. This was Schueler's first flight across the Atlantic, his first flight of real substance anywhere, and his crew's safe landing was undoubtedly a moment of personal triumph and intense relief. It is fair to assume that Schueler would have embraced the ground wherever he set down, but the honour fell to Scotland: his safe haven in a storm. The psychological imprint of this experience stayed with him for the rest of his life.

Molesworth was the 303rd's station for bombing raids in Europe, and remained Schueler's home base until he was invalided back to the US in September 1943.[2] More importantly, from his personal perspective, in London he befriended Bunty Challis, a young and rather attractive ambulance driver, who told him of her childhood holidays in the Scottish Highlands. She was not very articulate, Schueler later recalled, but even so "[she] would talk about its mountains and skies in images that reached dream images of mine".[3] This sense of Scotland as a place of dreams made real was one that lodged in Schueler's imagination throughout the 1940s and 1950s, and which became, in his own words, "The Scottish Vision",[4] a vision that would validate his inner feelings about art and nature, nature and abstraction. Schueler's enthusiasm for Scotland was fuelled by Michael Powell and Emeric Pressburger's romantic comedy *I Know Where I'm Going,* starring Wendy Hiller as a brisk young lady from London who loses her way on a Scottish island peopled by eccentric Highland types. Schueler loved the film and saw in the flickering black-and-white images of the skies the first real signs of the

**Fig. 24**
Jon Schueler
**Snow Cloud Over the Sound of Sleat**

(pl. 28, detail)

**Fig. 25**
Jon Schueler on the *Maasdam*, on his way to Scotland, September 1957

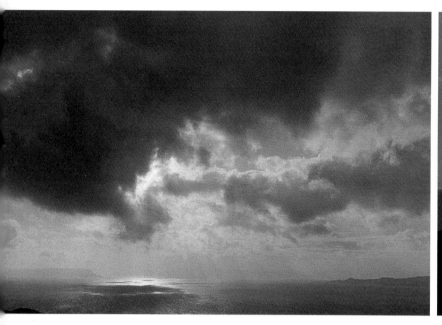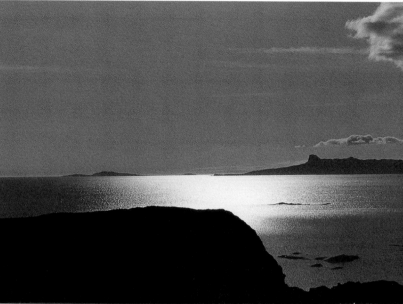

**Fig. 26**
The Sound of Sleat
and the islands of
Eigg, Rhum (centre)
and Skye, Scotland,
April 1972

**Fig. 27**
From the Rhue
Peninsula, Scotland,
looking towards
the islands of Muck
and Eigg (right),
April 1972

place he already had in his imagination. Throughout the 1950s friends recalled "his constant and insistent talk of this as yet unknown country",[5] but on 5 September 1957, having made some money from his first Leo Castelli gallery exhibition, he finally set sail for Scotland.

The forty-five paintings that Schueler made during that first Scottish winter of 1957–58 have been discussed already in this publication,[6] but it is worth noting Schueler's deep and instant response to the place where he made them. He first glimpsed the British Isles again as his ship passed the Scilly Isles: "Dimly seen views of sandy inlets and green fields – tantalizing like a striptease. The light of the sun breaking through silver white, hard on the turbulent water, blinding, hard and powerful. God, this is what I had come three thousand miles to see – and this was the first thing I saw!"[7] His excitement grew as he travelled north, uncertain of quite what he would find:

> I wasn't sure if it was a place or a mood or what it was, but there was something I was looking for
> ... As I approached the sea near Mallaig and the Sound of Sleat I could see these massive forms like
> the Isle of Eigg and the southern tip of the Isle of Skye and Rhum, and I could see these things sort
> of glowering in this kind of wild light that took place that day and the Geiger counter just went
> berserk. I'll never forget the excitement.[8]

At Mallaig on the west coast of Scotland Schueler found the physical manifestation of a world that he had long imagined. He might have found it closer to home, in Wisconsin perhaps, or northern Canada, but a romantic vision of Scotland had been somewhere in his mind for fifteen years, and by 1957 he was aching to make it real. Schueler was by his own account a nature painter, or was at least

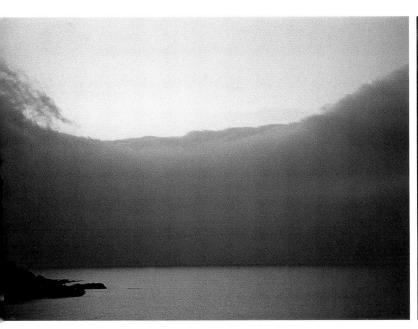 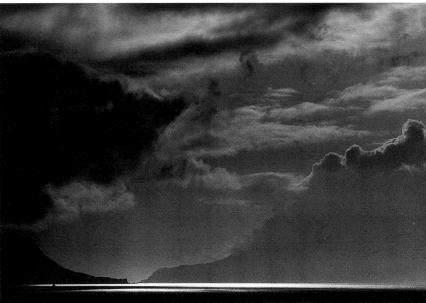

looking for a way to make paintings about nature, and at Mallaig – specifically in the skies above Mallaig – he found the landscape for which he had been searching. Nature, for Schueler, as he said on many occasions,[9] was all about the sky, and the sky itself was, in his wartime experiences, an almost tangible world: an actual place lived in and through with a navigator's sense of the ever-changing character of clouds and the weather. And that part of Scotland, the stretch of water known as the Sound of Sleat that runs between the Scottish mainland and the Isle of Skye, is a place where the climate is in a state of constant flux: bright sun giving way to rain storms; cloudbursts streaking the water with shards of silver light and then, in a moment, softening at the edges and disappearing into the veils and vapours of a soft grey haze.

The discovery of Mallaig was, for Schueler, a moment of truth that provided a personal proof that nature and Abstract Expressionism could co-exist. Nature had hitherto been a dirty word in New York art circles, a contradiction of the very freedom that abstraction was supposed to represent, but which for Schueler came with its own potent restrictions. Looking back on his early career he recalled that:

... trying for freedom could become just as contrived as trying for form ... It was around this time [Schueler is thinking back beyond his discovery of Mallaig to the early 1950s] that I said to myself, quite self-consciously, that I was painting about nature. Still, Rothko, Pollock and the others had broken through figuration and abstraction to feel the idea and freedom and power of non-objectivity. I wanted to break through the restrictions of non-objective thinking ... my "avant-garde" was to paint, not nature, but about nature.[10]

**Fig. 28**
The Sound of Sleat, Scotland, from a point near Schueler's studio, 1970

**Fig. 29**
The view near Schueler's studio in Mallaig, Scotland, looking across the Sound of Sleat to the islands of Eigg (left) and Rhum, 1972

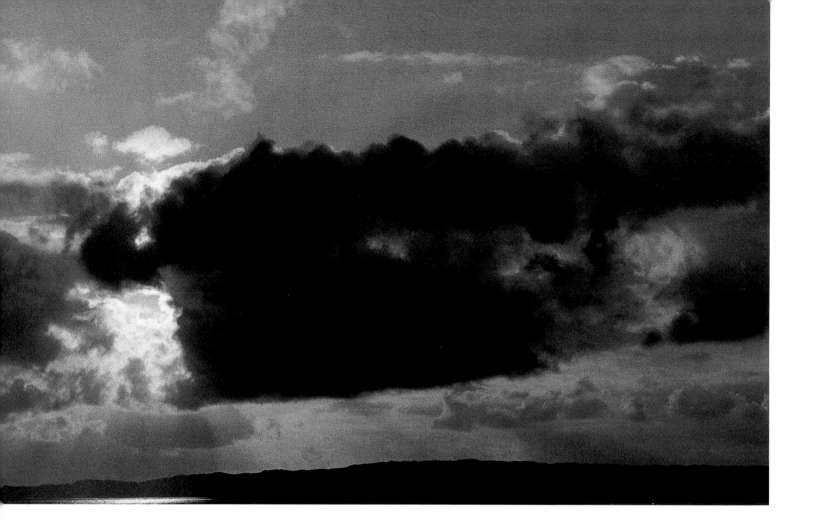

**Fig. 30**

The Sound of Sleat
and the Armadale
Peninsula of Skye,
Scotland, 1973

Schueler's terms of reference were remarkably similar to those of the English painter and critic Patrick Heron, one of the strongest voices of support for the American painting abroad, whose columns in the *New Statesman* and the American-published *Arts NY* established his reputation as one of the most forward-thinking and outward-looking critics of the time: "It's a terrible thing, to be bound by a rigid concept of what freedom should look like in a painting."[11] The debate between realism and abstraction, or "the Mirror and the Square" as it was dubbed by the Artists International Association (AIA) in London in 1952,[12] raged on both sides of the Atlantic, but Heron was one of the few to engage seriously with what was happening in New York. William Scott, who visited Pollock, Kline and de Kooning in 1953, was another, but it was not until 1956 that the Tate Gallery, London, presented a serious exhibition about New American Painting.[13] Both Scott and Heron were associated with a flourishing school of landscape-based abstract painting in and around the town of St Ives in Cornwall with which Schueler would have found sympathy, but he almost certainly knew nothing of its activities when he arrived in Britain in 1957, and there is nothing to suggest that he made contact with other artists during his stay. Indeed, one of the things he valued most about Mallaig was the state of enforced isolation that went with it: the absolute antithesis of his life in New York.

"I went to Scotland to live inside my paintings," he later said, "... to live inside the paintings I was struggling to paint."[14] But he also went to escape – to challenge himself with the remoteness of the place, with its emptiness and its tough, bleak beauty. In his romantic way Schueler idealized the local folk, whose livelihoods were hard-earned from the land and sea, and in particular the figure of Jim Manson, a local trawler skipper, who became something of a hero in Schueler's imagination and who took him to sea for five days aboard his boat, the *Margaret Ann*. Schueler wrote home to his wife Jody:

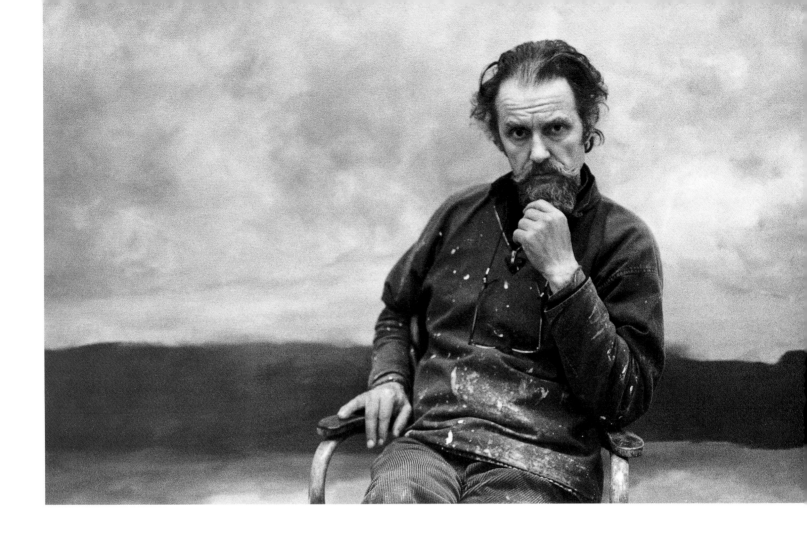

**Fig. 31**
Jon Schueler in his
studio in Mallaig,
Scotland, 1973

You should have seen me at the wheel of the Margaret Ann on Friday ... dusk, heavy sea, turbulent
tides and wind, boat pitching and rolling so that you could only stand up by hanging on, spray over
the decks and against the windows of the wheelhouse – you would have died a thousand deaths. I
loved it loved it loved it. If I ever give up painting it will be to go to sea.[15]

It was an experience that stayed with Schueler for the rest of his life, one that he repeated on later
occasions and which recalls the adventures of the nineteenth-century painter J.M.W. Turner, who
famously had himself lashed to the mast of a ship in the middle of a heavy storm. He did not, the
story goes, expect to survive, "but I felt bound to record it if I did".[16] It is well documented that
Schueler's first exposure to Turner came through Clyfford Still, and in Schueler's writings the names
of Still, Turner and Manson are often linked; indeed, they become a kind of talismanic chant that
punctuates his memoir:

Heroes:
Jim Manson
Clyfford Still
Turner.[17]

The concept of heroes, or influence of any sort, was almost as scorned in the world from which
Schueler had come as the idea of nature: "Nature and influence", Schueler recalled, were "ugly" and
"forbidden" words, and yet he wasn't afraid of either of them. Quite the opposite, in fact, and he

**Fig. 32**
J.M.W. Turner
**A Colour Wash
Underpainting**

*c.* 1824
Watercolour
22 × 29 cm
(8 ½ × 11 ½ in.)

embraced the influences that struck him most strongly: "I wanted the influence of Still or Turner or Monet or Goya or the cave drawing."[18] All of these helped to form the painter that Schueler became, but as the years rolled by it was Turner who became the most enduring presence at his shoulder.

By the time Schueler reached Paris in the summer of 1958, immediately after his first stay in Scotland, he had already given up his Clyfford Still-inspired palette knife and was working with brushes in layers and washes of almost feathery colour. In paintings such as *A Yellow Sun* (1958; pl. 25) and *Burning* (1958–59; pl. 27) it is the spirit as much as the look of Turner that seems most evocatively present. The works have a kinship with his towering skyscapes, particularly in view of the all-consuming centrality of the sun. For Turner the sun's power was everything, and the act of painting was a kind of alchemy that turned paint into light. His last words were reputedly "The Sun is God", which seems to have provided Schueler with the title of at least one of his paintings, *My Father is the Sun* (1958; pl. 24). There is a religious sense here, albeit of an almost pantheistic variety, for Schueler went beyond the sun to include all of nature within the scope of his 'vision'. As he later recalled, it was "my desire for the vision, my wanting to understand nature, my wanting to touch God, or God and Nature, or God in Nature."[19]

In Paris, Schueler's contact with a seminary of priests at Clamart gave a specifically religious context to this period of his life, and the priests' commissioning him to paint an altarpiece on the subject of The Passion gave tacit acknowledgement to the spiritual content of these sun paintings. That said, Schueler was not really a religious person, at least not in any denominational or doctrinal sense, although there was a kind of religious experience attached to his understanding of the Scottish landscape, and what he called his 'desire' for the 'vision' seems to have been rooted in his Scottish life.

Plates

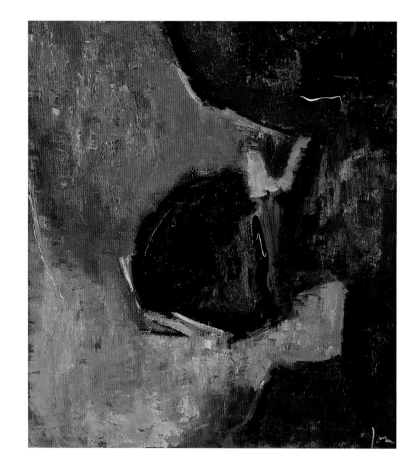

**Pl. 1**
**Memory of Love**

San Francisco, 1949
Oil on canvas
97 × 87 cm
(38 × 34 in.)
Inv. no. o/c 49-8

**Pl. 2**
**Untitled**

San Francisco, 1949
Oil on canvas
102 × 97 cm
(40 × 38 in.)
Inv. no. o/c 49-7

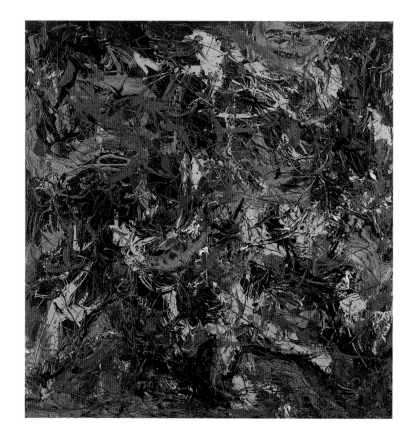

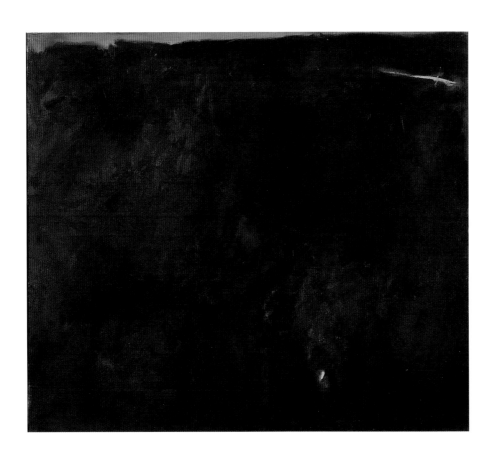

**Pl. 3**
**Toward Morning I**

San Francisco, 1950
Oil on canvas
122 × 140 cm
(48 × 55 in.)
Inv. no. o/c 50-13

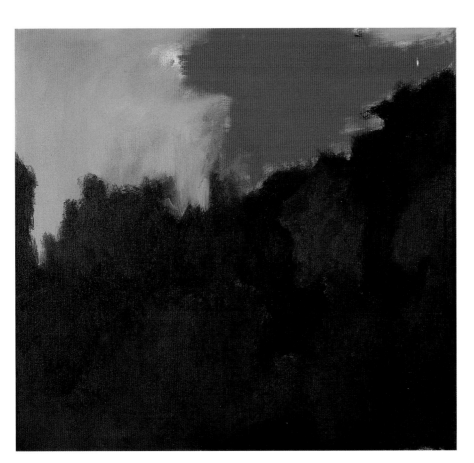

**Pl. 4**
**Untitled I**

San Francisco, 1950
Oil on canvas
112 × 122 cm
(44 × 48 in.)
Inv. no. o/c 50-11

**Pl. 5**
**Had He Seen It**

San Francisco, 1951
Oil on canvas
125 × 160 cm
(49 × 63 in.)
Inv. no. o/c 51-53

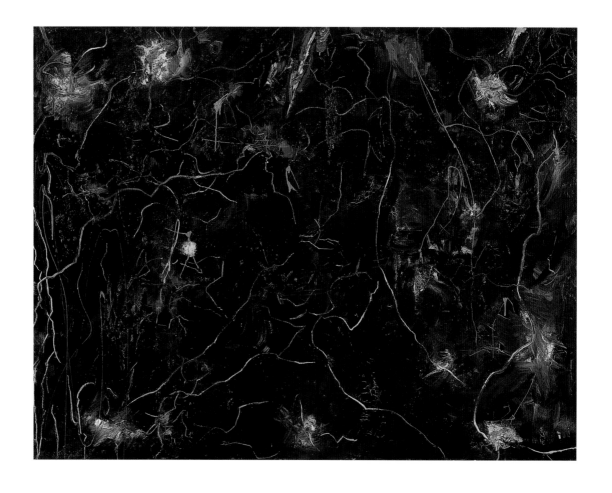

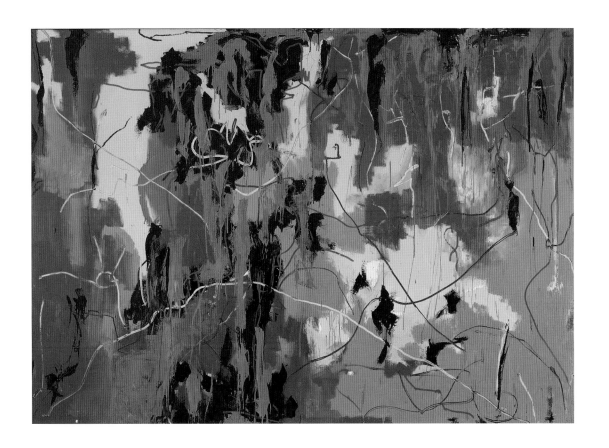

**Pl. 6**
**Umber on Orange
and Red**

New York, 1951
Oil on canvas
178 × 257 cm
(70 × 101 in.)
Inv. no. o/c 51-1

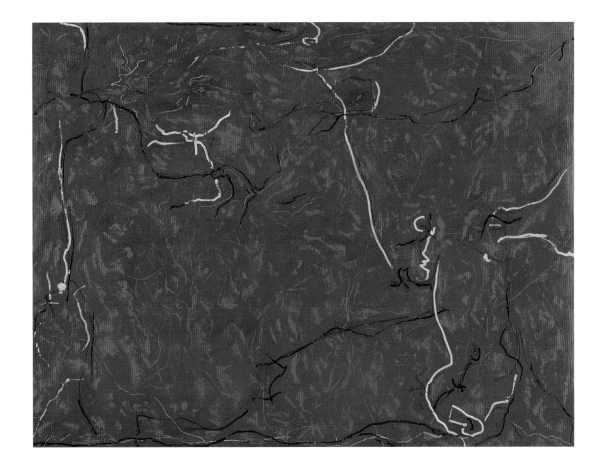

**Pl. 7**
**Red on Red**

New York, 1952
Oil on canvas
178 × 236 cm
(70 × 93 in.)
Inv. no. o/c 52-11

**Pl. 8**
**Orange and White**

New York, 1952
Oil on canvas
196 × 178 cm
(77 × 70 in.)
Inv. no. o/c 52-4

Detail opposite

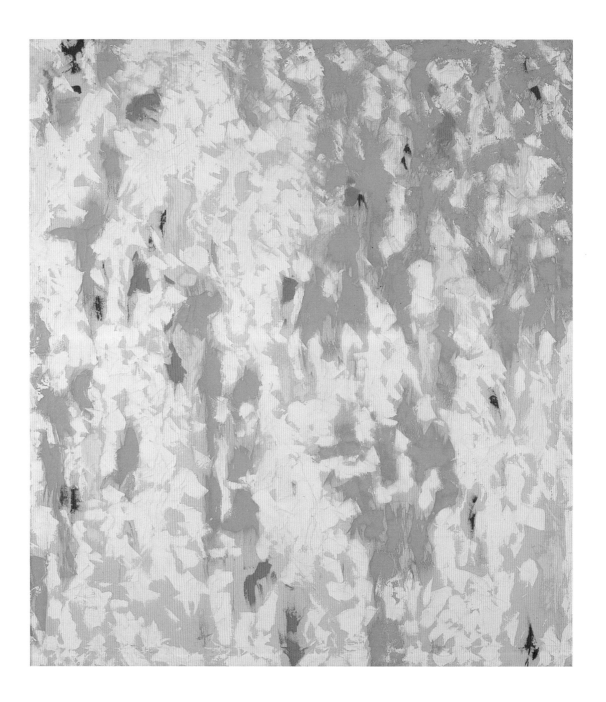

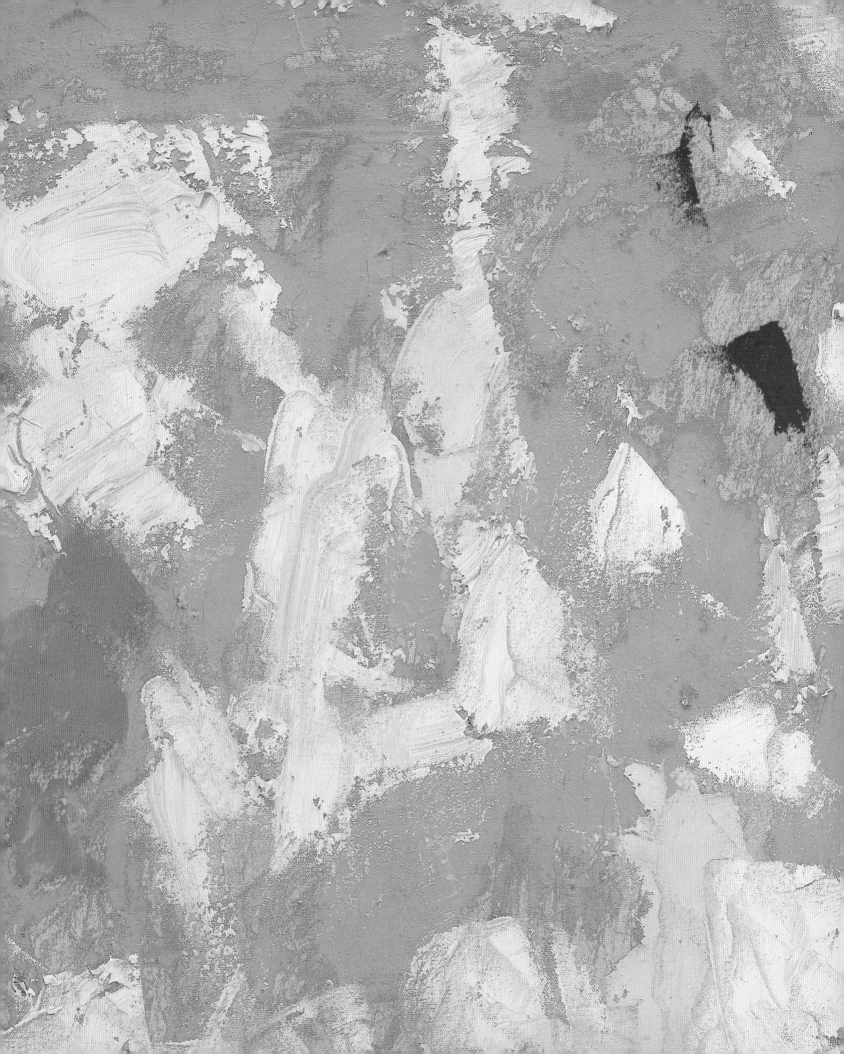

**Pl. 9**
**Red Storm**

New York, 1952
Oil on canvas
225 × 201 cm
(90 × 79 in.)
Inv. no. o/c 52-8

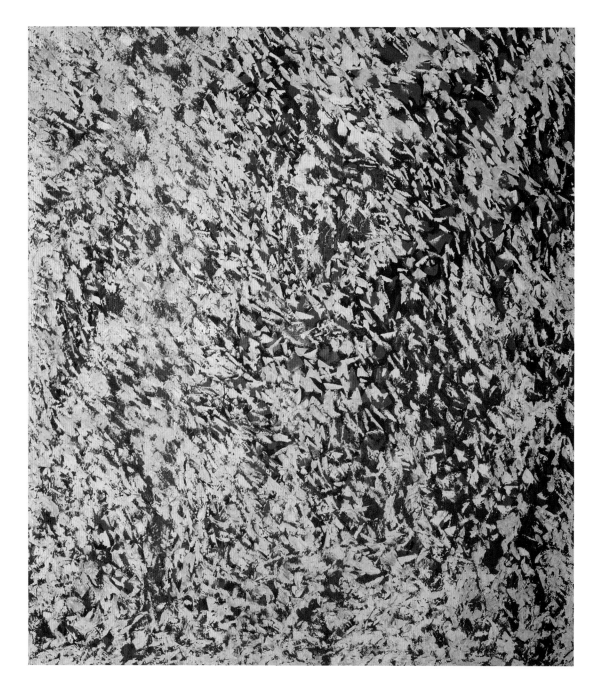

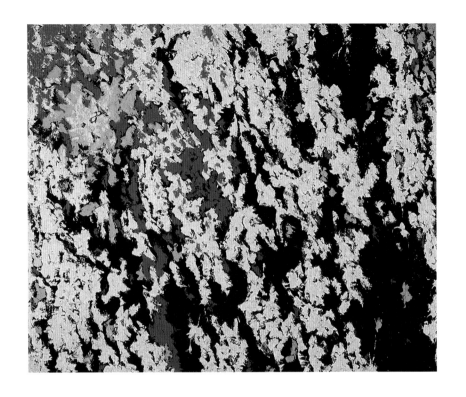

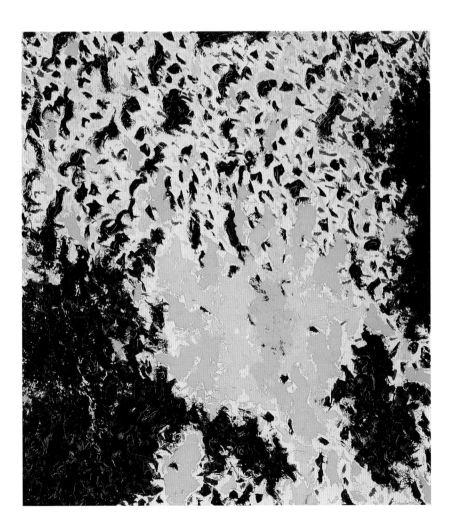

It was around this time [1951] that I said to myself, quite self-consciously, that I was painting about nature. Still, Rothko, Pollock, and others had broken through figuration and abstraction to feel the idea and freedom and power of non-objectivity. I wanted to break through the restrictions of non-objective thinking. But I wanted to use its freedoms. I wanted to include everything that might inform my mind. To include the marriage act, the dialogue between nature and this artist, as part of nature. I wanted to push through figuration into abstraction, and through abstraction into non-objectivity, and to come out the other side. My "avant-garde" was to paint, not nature, but about nature. To recognize that nature informed me, that my fantasy and imagery and paint itself could only be as true and informing as my own intense response and subjectivity.

At this time there began to flower another rebellion. There was in the air a feeling that one should, to find new forms, deny not only nature, but other painters, living and dead. I could not stand such restriction. And it became important for me to forget chronological history in my response, to accept every painter, from caveman to the present, as a contemporary, to accept or reject them as influences upon my work, not because of their places in art history, but because of their effect upon my sensibilities and my mind. I also wanted to have the freedom to show this influence, when the idea of "influence" was as ugly and forbidden a word as "nature." It seemed that if one could deny the words "nature" and "influence," it would mean that these did not exist. I wanted the influence of Still or Turner or Monet or Goya or the cave drawing or Joya's drawing to very much exist. In 1954 or 1955, I painted some small paintings after visiting the Frick Museum in New York which I called "Landscape after Turner." It was my public admission or advertisement of this idea, as well as homage to the excitement I had felt about Turner since seeing a portfolio of reproductions of late oils which Still had brought to class in 1948 or 1949.

When I saw the Turners through the years since and compared them with other work, it has seemed to me that he went further into nature and further into the sensation of nature in paint than any other painter. He, the stylist of incredible facility, did most to break down style, to destroy it, to find the possibility of paint talking as paint, as an extension of the most immediate perception and sensibility, so that it became most like nature. Not a painting of nature, but a painting most like nature. This is what I would like my painting to be. If I should succeed, I shall have gone further than Turner. But at any given moment in my painting, I don't know what that means. I can't.

**Romasaig,
24 November
1970**

*The Sound of Sleat:
A Painter's Life,*
pp. 222–23

Abby and I met Jon in the best way to meet an artist – through his work. We bought a 1955 painting, *Sun and Fog* [pl. 15], at the Stable Gallery annual in December of that year. At a party a few weeks later we mentioned the purchase to Franz Kline. "Good painter," he said. His bright dark eyes danced around the room, rested, and returned to us. "Would you like to meet him?" Franz introduced us to a slim, clean-cut, clean-shaven fellow just under forty. Within moments we invited Jon to our apartment for a nightcap and to see his painting.

Jon set a fast pace going to our place, then raced through our living room as he looked this way and that for *Sun and Fog*. He didn't slow down until the bedroom. There, his painting hung opposite our bed on a wall washed by a bank of lights controlled by a dimmer. "Do you mind?" he asked, carefully stretching out on the bed so that his feet hung over the bottom. We must have stayed there fifteen or twenty minutes while, at his request, Abby and I turned the dimmer up and down to emphasize the painting's sunny yellows and its dark foggy reds. He obviously loved this work – there was no false modesty about that – and he just as obviously loved its new setting. He talked, almost without pause, about finding his inspiration in nature – and, more specifically, in the sky – while at the same time making it clear that he didn't paint from nature, that his wasn't a sky he had seen but one he had created.

That night Jon laid the foundation for a dialogue that would continue between us for thirty-six years – a dialogue in which, on the surface, his romantic identification with nature, particularly with its changing and dramatic manifestations, seemed to be the antithesis of my own identification, then and for a few more years, with rigidly geometric office buildings placed squarely in Manhattan bedrock. As our friendship became closer, we dug beneath the surface and began to recognize that each of us was equally involved with permanence and change, that indeed both painting and writing attempt to impose permanence on change, order on chaos, no matter if trying to capture the transience of the weather, in paint, or of the mood, in words.

From
B.H. Friedman's
talk at the
memorial
gathering for
Jon Schueler,
31 October 1992

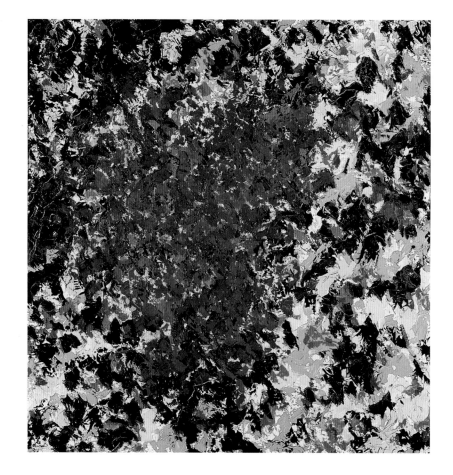

**Pl. 12**
**Counterpoint**

New York, 1953
Oil on canvas
127 × 122 cm
(50 × 48 in.)
Inv. no. o/c 53-2

**Pl. 13**
**Orange Night**

New York, 1955
Oil on canvas
213 × 225 cm
(84 × 90 in.)
Inv. no. o/c 55-2

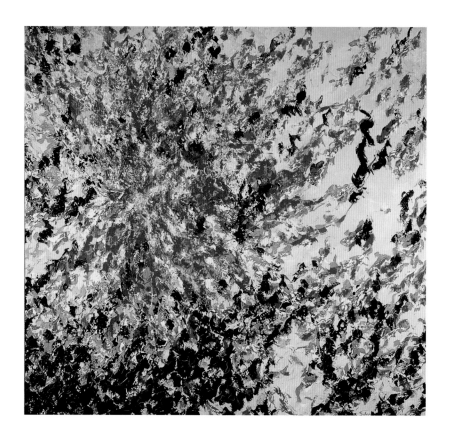

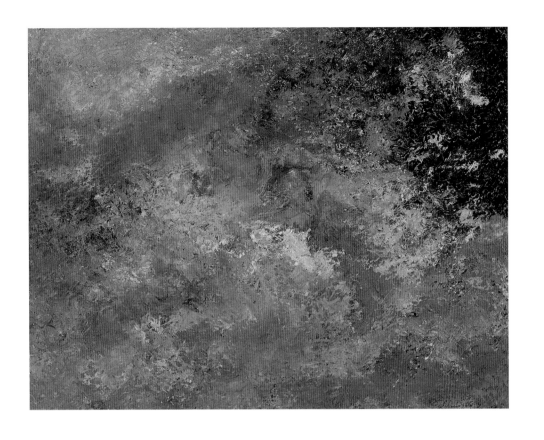

**Pl. 14**
**Night III**

New York, 1956
Oil on canvas
102 × 132 cm
(40 × 52 in.)
Inv. no. o/c 56-10

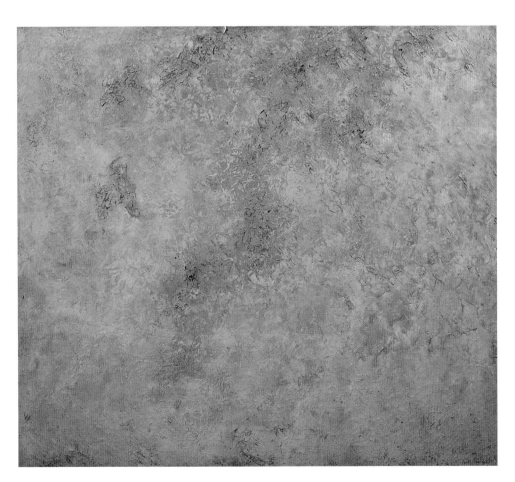

**Pl. 15**
**Sun and Fog**

New York, 1955
Oil on canvas
122 × 137 cm
(48 × 54 in.)
Inv. no. o/c 55-7

**Pl. 16**
**Windswept**

New York, 1956
Oil on canvas
123 × 157 cm
(48 × 62 in.)
Inv. no. o/c 56-32

Detail opposite

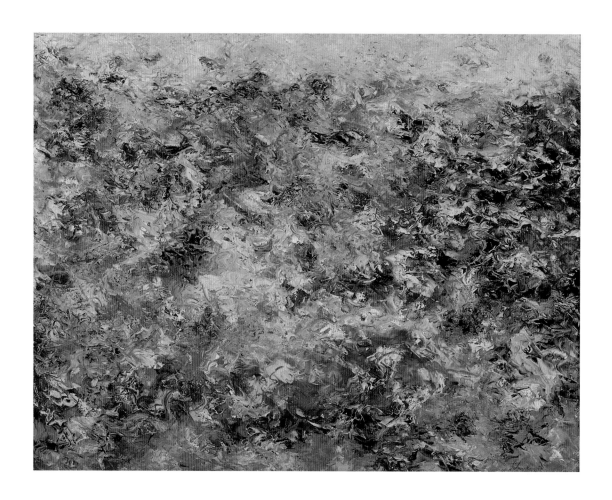

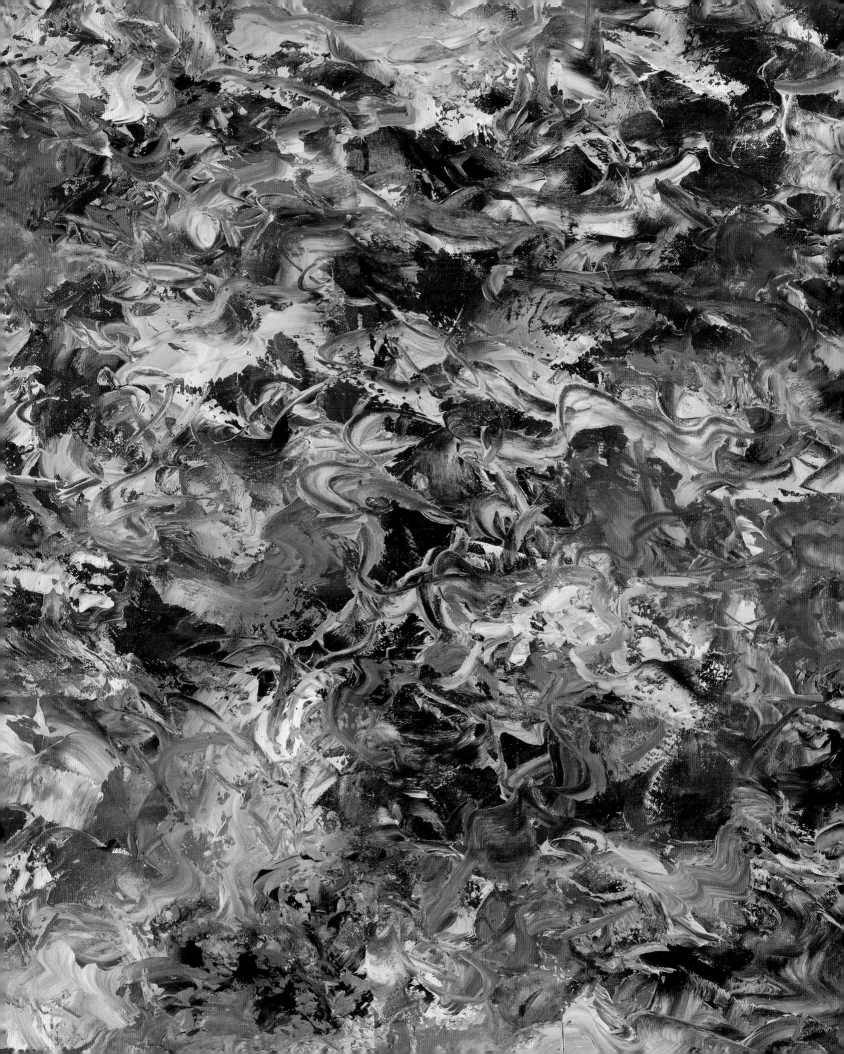

**Pl. 17**
**Transition II**

New York, 1956–57
Oil on canvas
104 × 89 cm
(41 × 35 in.)
Inv. no. o/c 57-3

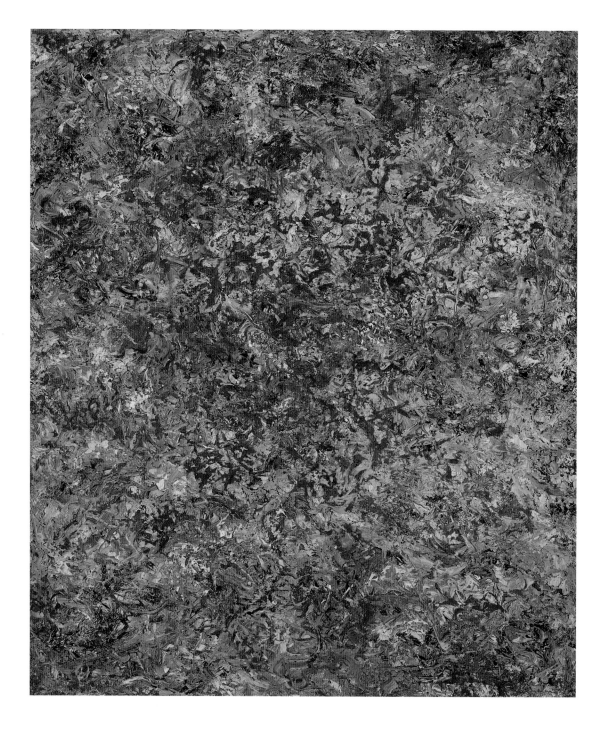

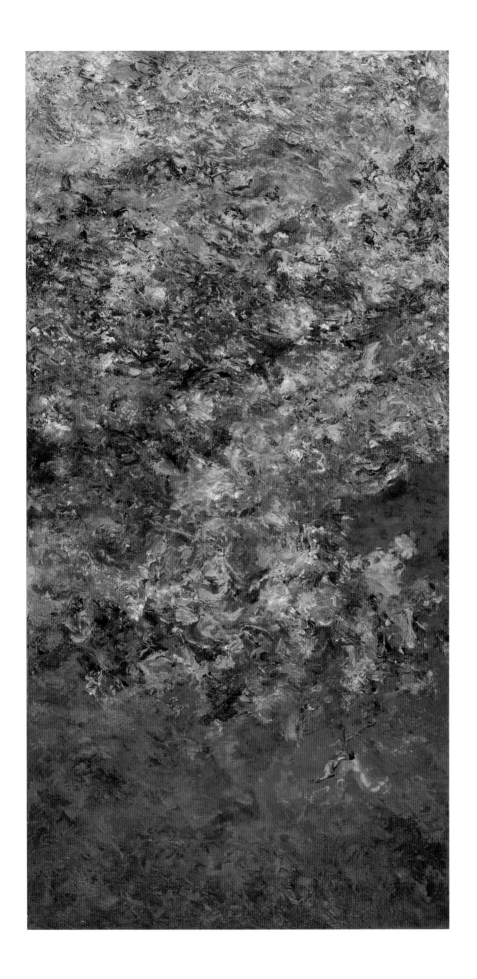

**Pl. 18**
**Evening I**

New York, 1957
Oil on canvas
244 × 122 cm
(96 × 48 in.)
Inv. no. o/c 57-5

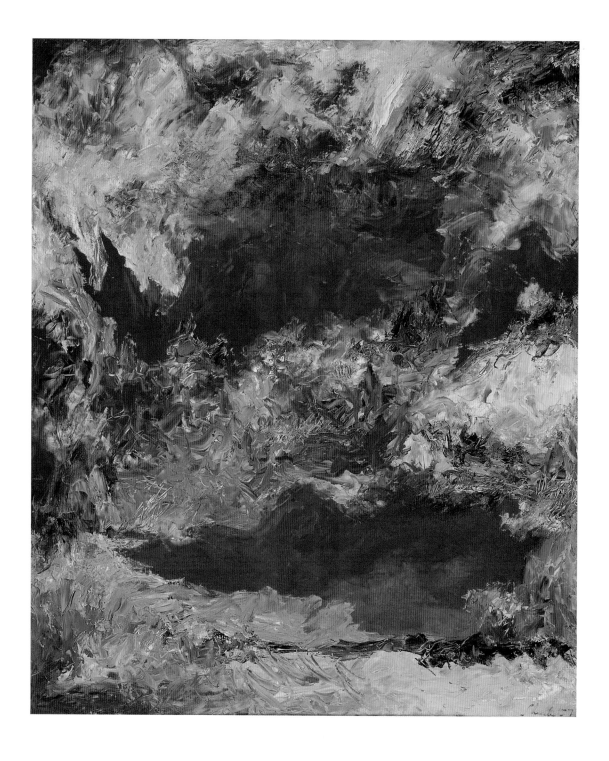

**Pl. 19**
**My Garden is**
**the Sea**

Mallaig, 1957
Oil on canvas
183 × 152 cm
(72 × 60 in.)
Inv. no. o/c 57-50

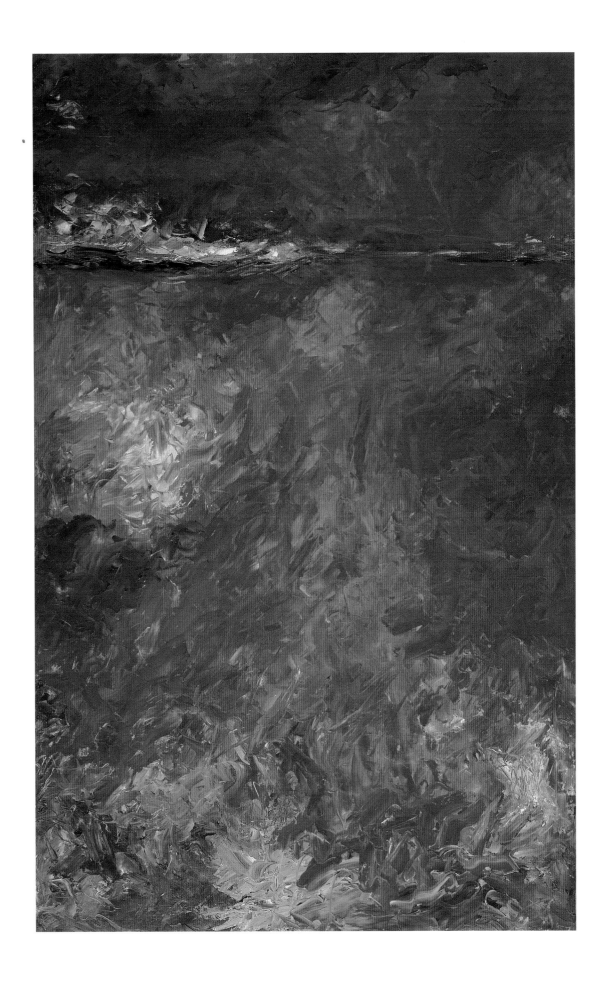

**Pl. 20**
**The Sound**
**of Rhum**

Mallaig, 1957
Oil on canvas
201 × 127 cm
(79 × 50 in.)
Inv. no. o/c 57-44

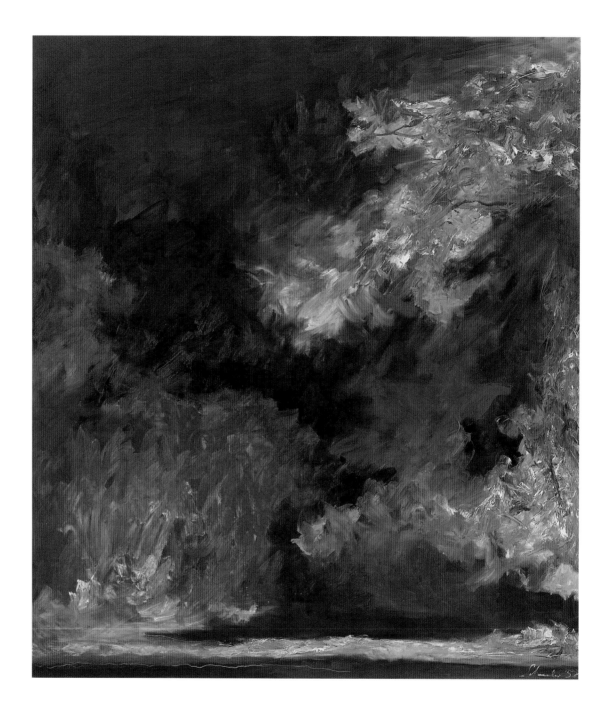

**Pl. 21**
**Snow Cloud and**
**Blue Sky**

Mallaig, 1958
Oil on canvas
203 × 180 cm
(80 × 71 in.)
Inv. no. o/c 58-13

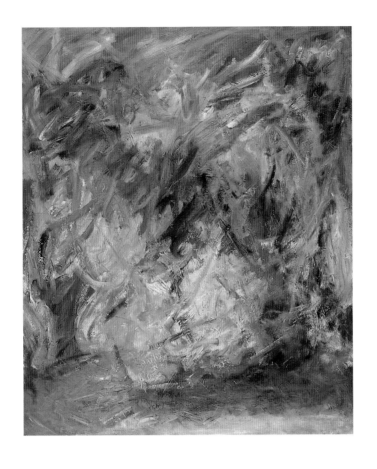

**Pl. 22**
**Winter Storm**

Mallaig, 1958
Oil on canvas
201 × 168 cm
(79 × 66 in.)
Inv. no. o/c 58-9

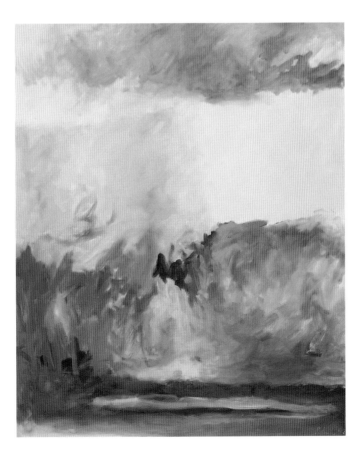

**Pl. 23**
**Sun Leaving**

Arcueil, 1958
Oil on canvas
232 × 191 cm
(91½ × 75 in.)
Inv. no. o/c 58-52

Some of the paintings I did in Clamart in 1958 are among my best. It was a curiously intense painting experience, and I think that it made me understand something about painting which I had only dimly recognized before, or had verbally acknowledged. I'm not sure I can find the words, but I'll try. It was a matter of carrying commitment to its greatest extreme. One day in Clamart I looked around me at the bare floors, the one hard chair, the palette table, the easel, the canvases, and I said, My God, I have no life. I have only painting. No life. I felt completely cut off from life. I seemed to know no one, see no one, all I did was paint. If I did not paint I was sunk in a kind of gloomy, dull detachment. When I painted I came alive and everything – absolutely everything – went into the painting. (Not always, of course, but when the steam was worked up, when I found my attention and concentration total, when I moved all the way into the dream of my work.) I could understand, I thought, what van Gogh had gone through in all of his last work. The terrible loneliness which characterized the man, but which enabled or compelled him to bring all of his forces, all of his mind, all of his emotions, to bear on the canvas. It must have been that which drove him mad. I ended my stay in Clamart when I began to feel that should I paint much more, I'd be painting myself into the canvas, and there would be no one left outside of the canvas to paint. It was a powerful and thrilling creative experience. In my imagination I had not left people. They crowded my mind. My fantasy life was full of thoughts and feelings about friends, women, art world figures. But it was all swirling together into an image on the canvas.

My strength lies in my humor, in my flexibility, in my ability to laugh, to rebound, to start all over at the beginning after the worst disaster, my eternal optimism, my belief in my powers, the possibility of a communion between myself and nature. Moreover, my strength is my ability to perceive the connection between that which makes life most exciting and meaningful to me and that which makes it most difficult. I respond to many women with a sensitivity which often is all too much for me; and possibly for them, too. I don't even know what I respond to. I feel the death in some of them, perhaps – death or tragedy or loneliness that they don't even know is there. Or the rage or the destructiveness or the tenderness or the warmth. But I can't predict my reaction. Sometimes a woman will seem to draw from me a hurt which on the surface neither of us want. Or a demand for protection. Withal, I have never become bored with women, I enjoy them, I still search them as well as the sky and man's thought for the mystery. It's all life, and it's all lust and feeling and laughter and power and thought, and I wouldn't miss any of it.

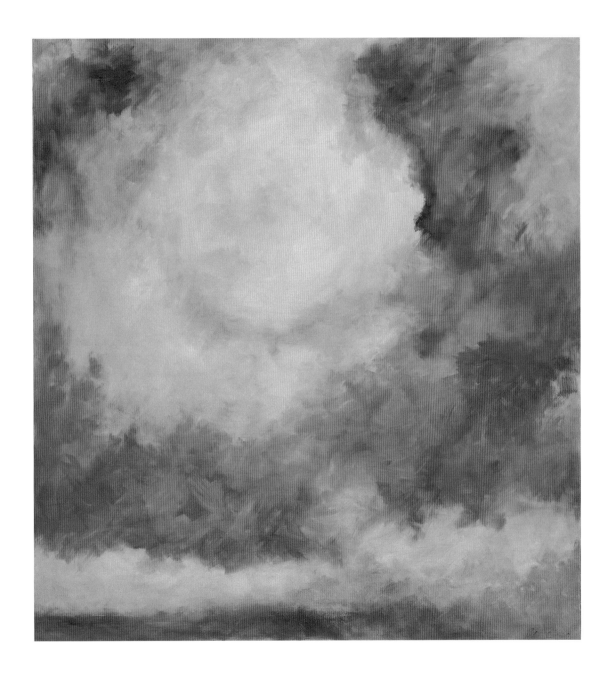

**Pl. 24**
**My Father is**
**the Sun**

Clamart, 1958
Oil on canvas
201 × 186 cm
(79 × 73 in.)
Inv. no. o/c 58-37

**Pl. 25**
**A Yellow Sun**

Arcueil, 1958
Oil on canvas
201 × 185 cm
(79 × 73 in.)
Inv. no. o/c 58-55

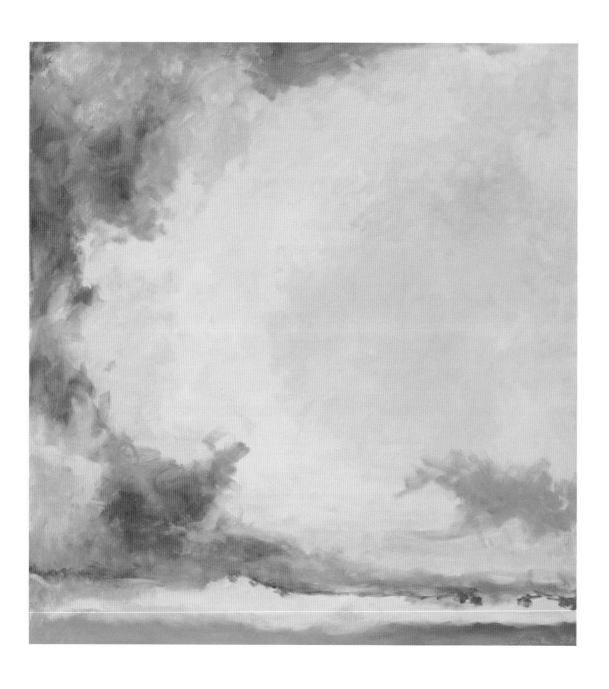

I remember the memory of North. I remember summer vacation time in childhood, when the family would head North in the car for the big adventure. I remember the farms near Milwaukee, and then farther along, 150 miles or so, the ribbon of highway moving through the hills, the forest land, tall pines, shimmering lakes. I remember the fresh feeling of pine air, the brightness of sky and tree, and the deepening mystery as we drove North. I wanted to go very far North. When we would finally stop at a lake resort or at Fish Creek on Sturgeon Bay, I would suffer a disappointment, knowing that further on, perhaps only fifty or a hundred miles or so, would be the North I wanted to find, hard, cold light, true mystery, freedom, the Word. Everything would be large and wonderful and free in the North. Heaven and God would be there and adventure, and my heart would be able to expand, my mind to float free. The prison of the family would break asunder, and I'd hike through the forests and move across the lakes and go further and further into a steel grey sky, toward the cool light of the horizon.

I was imprisoned in my childhood. (Am I still?).

The North

**New York,
5 April 1962**

*The Sound of Sleat:
A Painter's Life,*
pp. 125–26

More and more I've considered that working is the point of work, and that all else is incidental. Compared to the work in the studio, the rest of living is a passive act. Extremely passive. I say that advisedly. Looking at the sky, walking the moors, fighting wars, making money, building houses, teaching students, all these are passive acts compared to the act in the studio.

The residue of the struggle is the painting or the poem. It has an existence outside of the artist, who can join others in contemplating it, feeling it, having it become part of the passive act of living. In his next painting, the artist might struggle with an impulse of nature, or with the impact of some past painting (his own or another's) on his mind. What questions are raised by the sound of silver-grey light outlining the Sleat Peninsula, or by the death of a mother, or by Magda's hand, or by a Goya drawing, or by a Turner sea and sun, or by "The Woman in the Sky," "Red Snow over the Sound of Sleat," or "Magda Series: June Night"? All reality, including the reality of the painting, raises unanswerable questions. The struggle to create an image as real as the idea (not an image of the idea) is the point of the artist's life. In this struggle, the artist creates himself.

Black.

The Night Sky.

Birth: From the womb into the night of day.

**Romasaig,
14 November
1970**

*The Sound of Sleat:
A Painter's Life,*
pp. 192–93

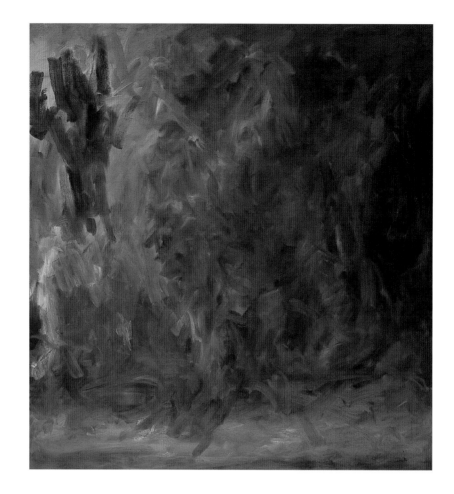

**Pl. 26**
**December Blue**

Arcueil, 1958
Oil on canvas
183 × 170 cm
(72 × 67 in.)
Inv. no. o/c 58-50

**Pl. 27**
**Burning**

Arcueil and
New York, 1958–59
Oil on canvas
180 × 201 cm
(71 × 79 in.)
Inv. no. o/c 59-2

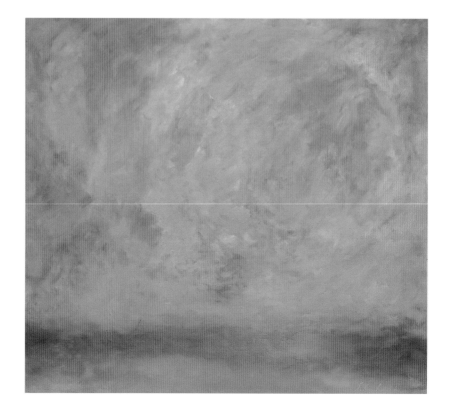

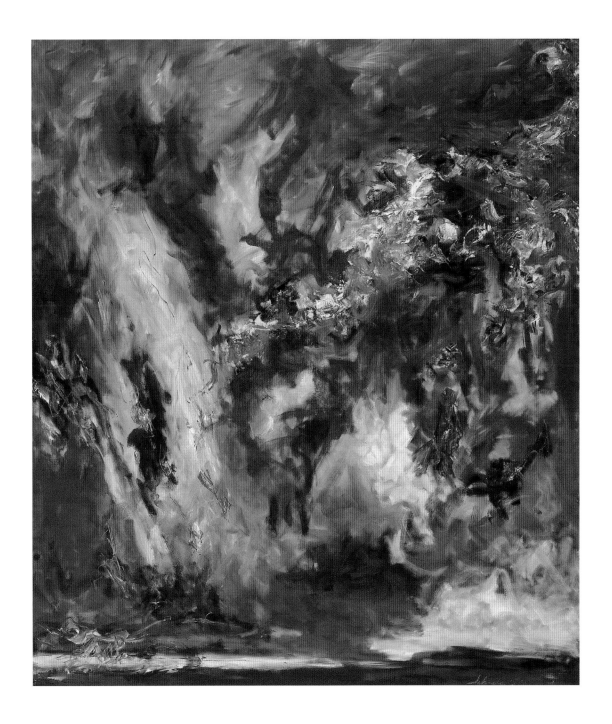

**Pl. 28**
**Snow Cloud**
**Over the Sound**
**of Sleat**

New York, 1959
Oil on canvas
228 × 198 cm
(89¾ × 78 in.)
Inv. no. o/c 59-13

**Pl. 29
September
Crossing**

Guilford CT, 1960
Oil on canvas
200 × 230 cm
(78¾ × 90½ in.)
Inv. no. o/c 60-15

Detail opposite

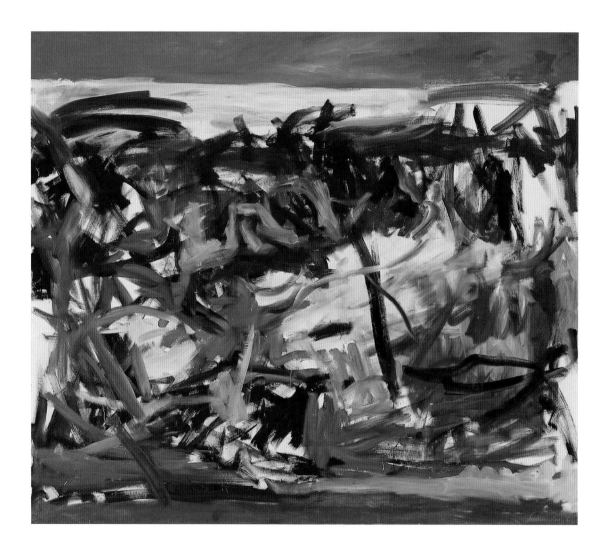

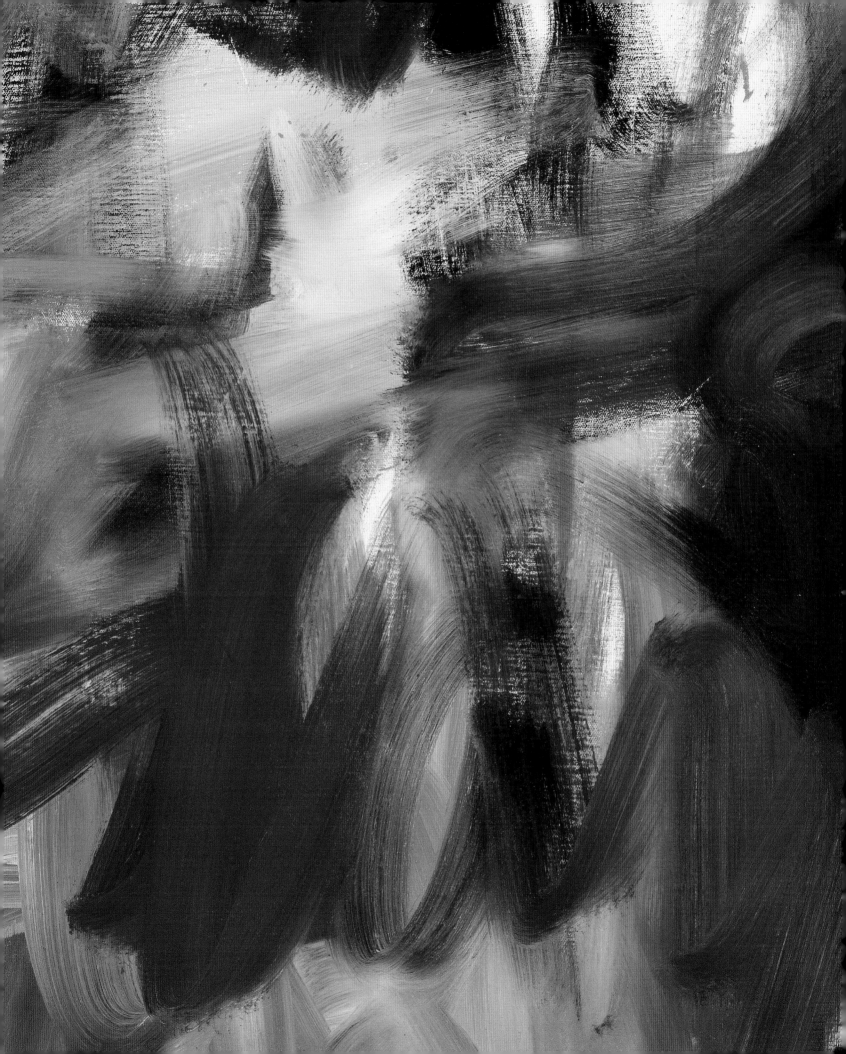

**Pl. 30**
**Night Sun**

Guilford CT, 1961
Oil on canvas
183 × 152 cm
(72 × 60 in.)
Inv. no. o/c 61-3

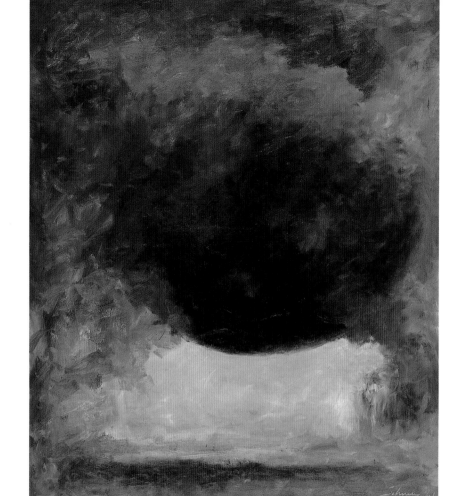

**Pl. 31**
**Winter:**
**Leete's Island**

Guilford CT, 1961
Oil on canvas
122 × 173 cm
(48 × 68 in.)
Inv. no. o/c 61-8

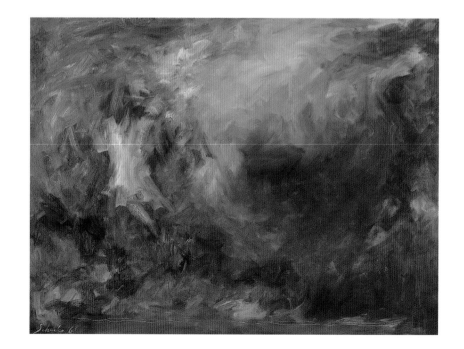

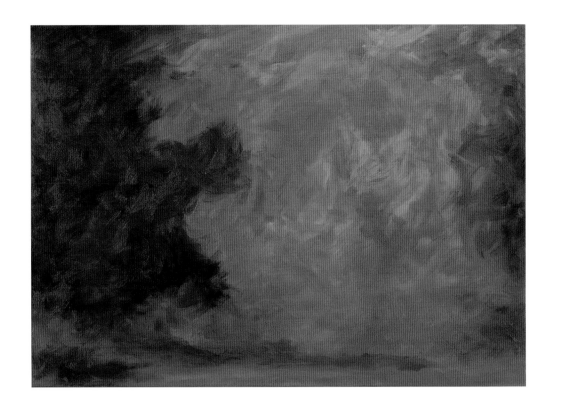

**Pl. 32**
**Gale on Sunday**

New York, 1961
Oil on canvas
129 × 183 cm
(50¾ × 72 in.)
Inv. no. o/c 61-10

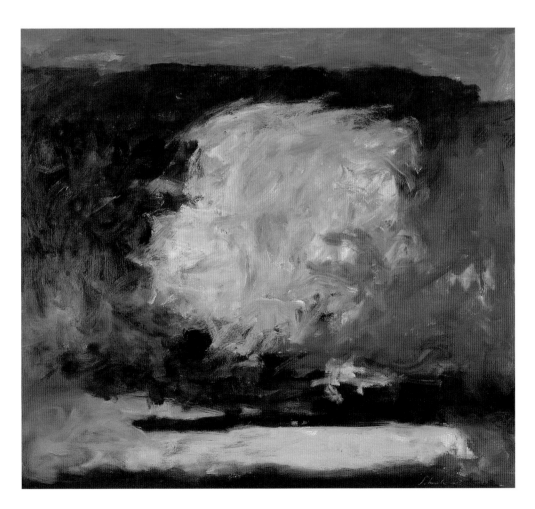

**Pl. 33**
**(In Memoriam)**
**Mourning in**
**November**

New York, 1963
Oil on canvas
193 × 216 cm
(76 × 85 in.)
Inv. no. o/c 63-2

**Pl. 34**
**Sonia Sleeping**

New York, 1964
Oil on canvas
191 × 232 cm
(75 ¼ × 91 ½ in.)
Inv. no. o/c 64-3

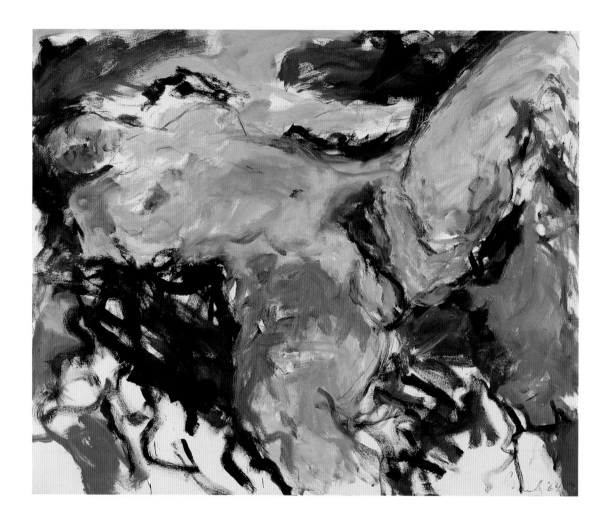

Having been in Maine for a few weeks, I realize that the Scottish landscape is the only one that I have a real passion for. I love it here, and there is much to look at. But my very own is in Mallaig, and that is that. What's more, I find that I look forward to New York with great anticipation. I hope that I shall be able to get the large studio on 20th and Broadway. Suddenly, I want New York and people, and I want to add the dimension of people to my work. Before I left I started a couple of canvases using the figure as a basis, and now I would like to really plunge into the figure theme. I want to get a number of models and do lots of drawings, watercolors, and other studies, and stretch up canvases large and small and see what I can do. I have always thought that because of my nature theme, there was nothing for me to paint in New York. Now I realize that Woman is in New York, and I can paint about that with as much passion as I painted about the sky in Scotland. I'll bring the two together. In any case, I'm now excited about the coming year and don't see it as some long wasteland before I finally extricate myself for the dream of Scotland. Moreover, I'm bound and determined to end the false dream of marriage, which I always have used as some kind of sop for my loneliness. The loneliness will have to remain and will have to go into the picture. I might as well enjoy myself knowing lots of women. I like to know them and I like to romance them, just as I like to look at the sky. But I sure in hell don't want to ruin my life for them. Let them become part of my picture.

One afternoon when Mary was away, I started a large painting from a memory of the night before: Mary in an attitude of abandon, head thrown back, legs spread. It's still in its beginning stage, and confronts me in my studio, inadequate in the extreme on any painterly level, but containing a kind of robust challenge. A movement of red between the legs is like a flame, and the sensuality of gross size and abandon is there. When Mary returned late that afternoon I held her in my arms and cupped her breasts, and said, "What's happened to you, baby, you seem so small." I had lived with the Mary image on the canvas throughout the afternoon – the fantasy image, expanding as in a dream from the nearness of my eyes to her body the night before. Breasts like mountains, belly massive, thighs huge plains of flesh, a landscape, red, autumn yellows, confused and convulsive. The breasts now in my hands, though full, seemed small in comparison. The girl was a girl, a human being to be enfolded and sheltered; the painting was a landscape, tempting and threatening, in which I would become submerged in my struggle to dominate it.

**Stonington ME,
17 August 1962**

*The Sound of Sleat:
A Painter's Life,*
p. 135

**New York,
3 January 1963**

*The Sound of Sleat:
A Painter's Life,*
pp. 136–38

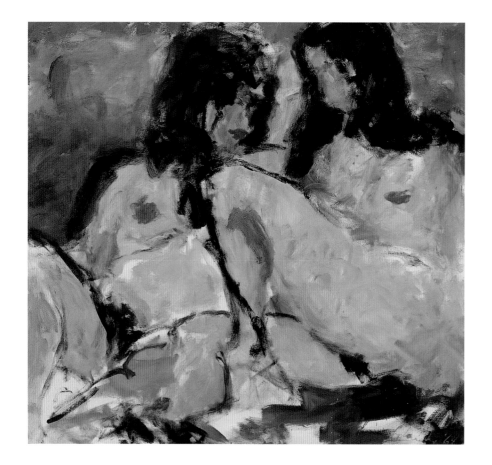

**Pl. 35**
**Two Women**

New York, 1964
Oil on canvas
173 × 185 cm
(68 × 73 in.)
Inv. no. o/c 64-9

**Pl. 36**
**Two Women and**
**the Sea**

New York, 1964
Oil on canvas
172 × 191 cm
(67 ¼ × 75 ¼ in.)
Inv. no. o/c 64-24

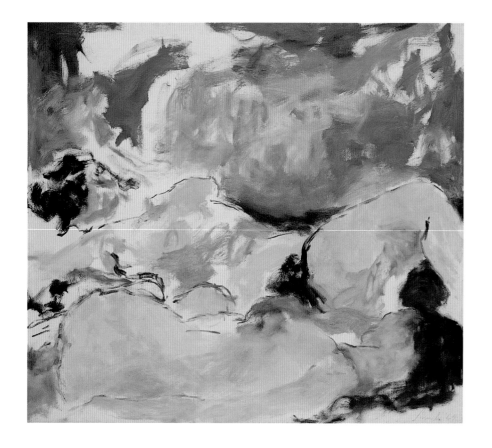

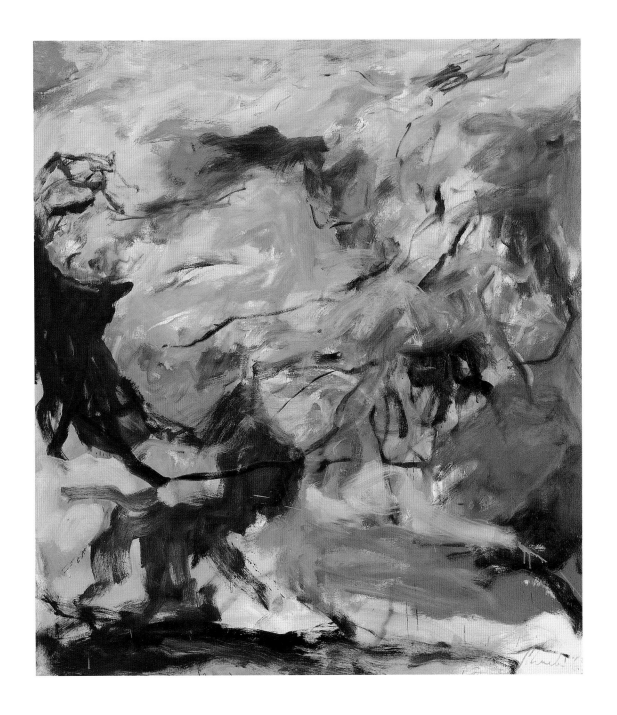

**Pl. 37**
**Woman in a**
**Yellow Sky**

New York, 1965
Oil on canvas
193 × 173 cm
(76 × 68 in.)
Inv. no. o/c 65-10

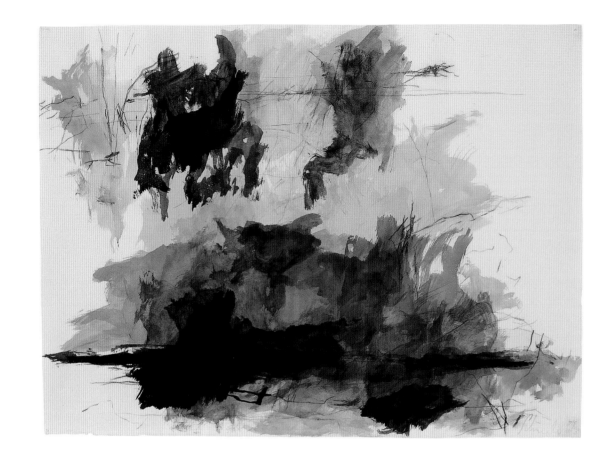

**Pl. 38**
**Black Clouds:**
**Shadows**

Tokavaig, 1967
Watercolour
and crayon
61 × 76 cm
(24 × 30 in.)
Inv. no. w/c 67-

**Pl. 39**
**August 5, 1967, III**

Tokavaig, 1967
Watercolour
56 × 76 cm
(22 × 30 in.)
Inv. no. w/c 67-

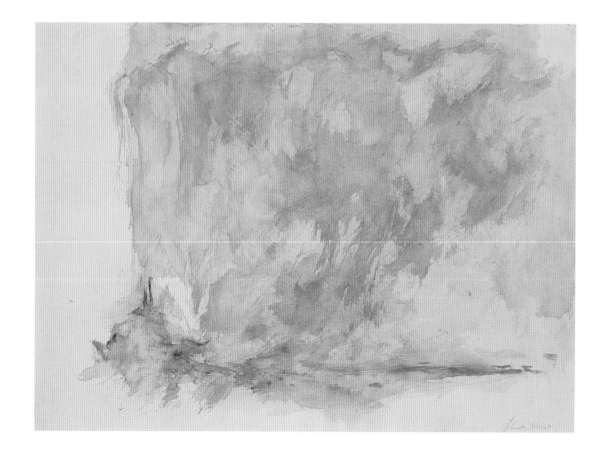

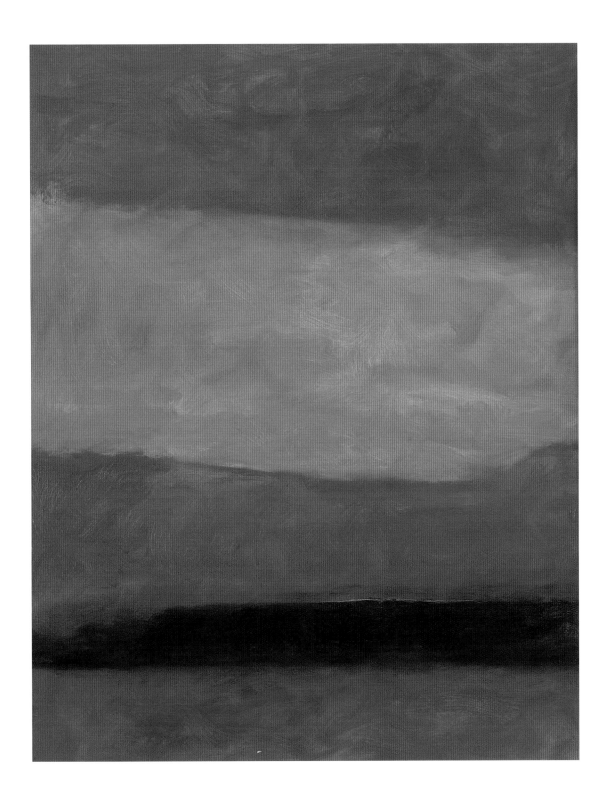

**Pl. 40**
**Felt Red in Sound**

Chester CT, 1968
Oil on canvas
152 × 119 cm
(60 × 47 in.)
Inv. no. o/c 68-17

**Pl. 41
Fantasy:
Snow Cloud I**

Chester CT, 1968
Oil on canvas
131 × 165 cm
(51½ × 65 in.)
Inv. no. o/c 68-35

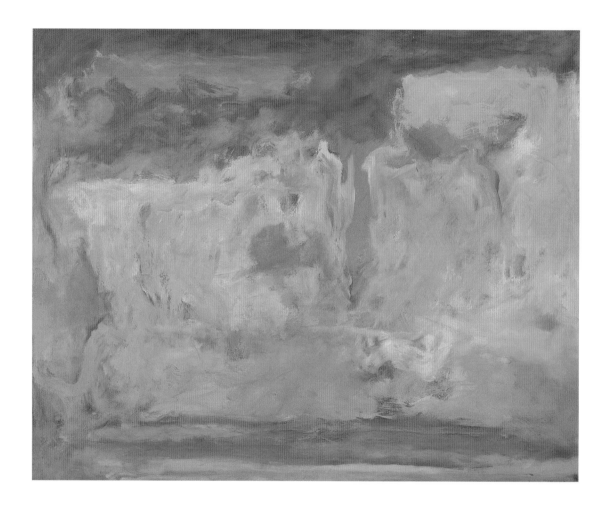

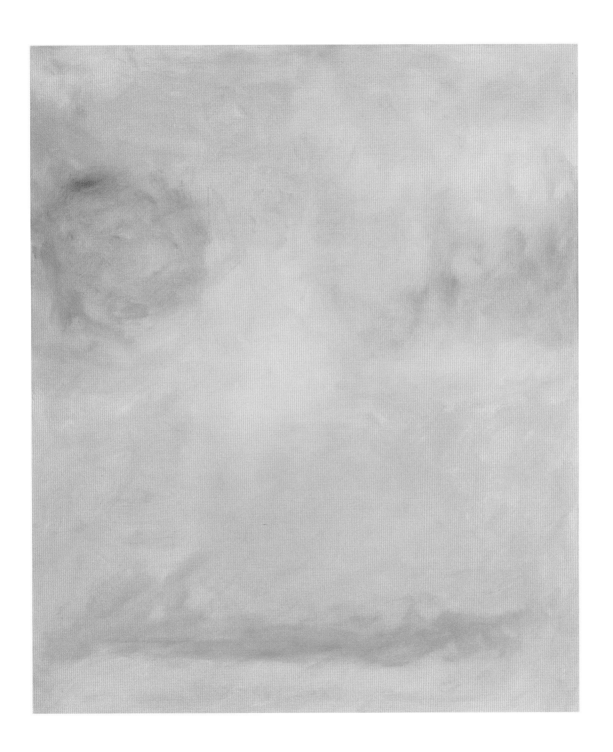

**Pl. 42**
**Sing Yellow**

Chester CT, 1968
Oil on canvas
152 × 130 cm
(60 × 51 in.)
Inv. no. o/c 68-40

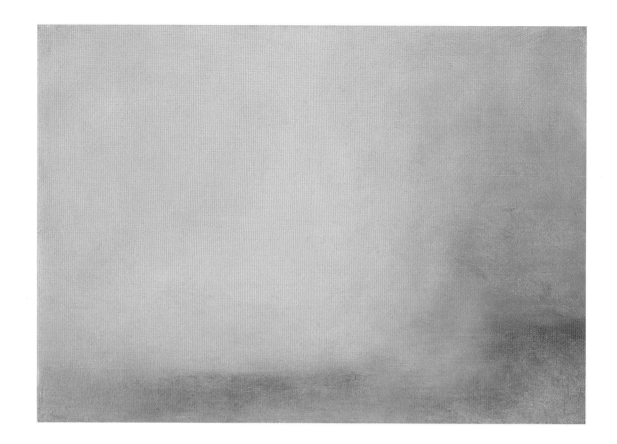

**Pl. 43**
**Sleat Veil I**

Chester CT, 1969
Oil on canvas
36 × 51 cm
(14 × 20 in.)
Inv. no. o/c 69-17

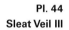

**Pl. 44**
**Sleat Veil III**

Chester CT, 1969
Oil on canvas
46 × 61 cm
(18 × 24 in.)
Inv. no. o/c 69-33

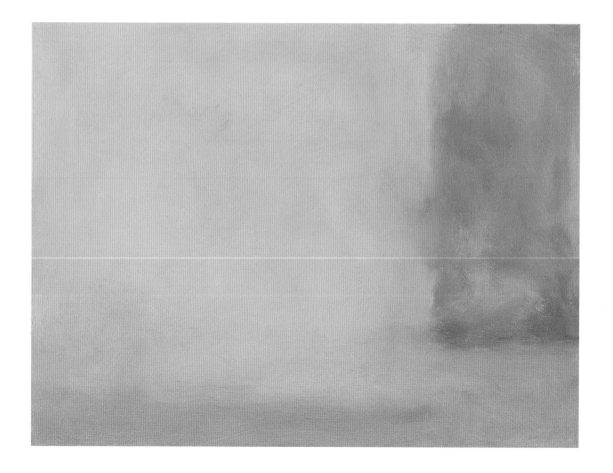

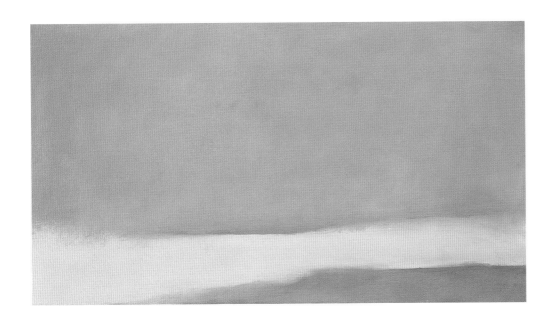

**Pl. 45**
**Northern Sound**

Chester CT, 1969
Oil on canvas
41 × 61 cm
(16 × 24 in.)
Inv. no. o/c 69-46

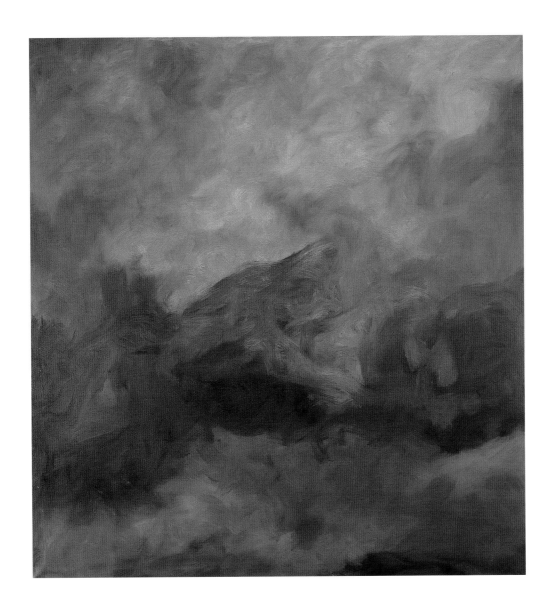

**Pl. 46**
**Night Sky:**
**October II**

Mallaig, 1970
Oil on canvas
201 × 191 cm
(79 × 75 in.)
Inv. no. o/c 2

**Pl. 47**
**Light: Summer II**

Romasaig, 1970
Oil on canvas
160 × 178 cm
(63 × 70 in.)
Inv. no. o/c 6

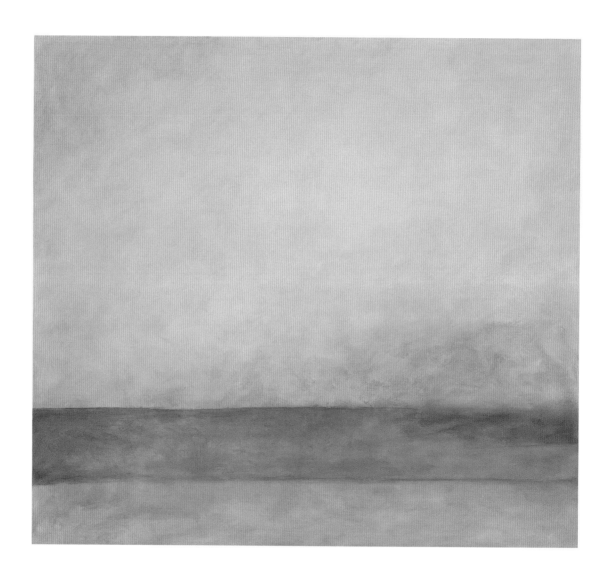

However, it was in my Chester studio that I started painting the small, grey paintings. For years my work had been getting larger and larger until the 11 by 21 foot Woman in the Sky paintings of 1966. In 1967 I worked on the watercolors in Skye and I think that these opened up the idea of small size for me. I don't turn my back on large size. It is a powerful experience to work over an area which is beyond one's control, which cannot be seen all at once, which seems like a huge landscape or like passing islands and lochs at sea, never quite being able to contain the complex relationships. But because I had been painting large, the idea of working small was a challenge, an invitation to adventure. Along with that came the challenge of working in grey. This went back to dreams of the early black paintings. But it was also a result of looking at the Mallaig skies and the snow clouds and the fogs in Chester, Connecticut and seeing them constantly in terms of color. Color burned in my mind's eye. Now I wanted to explore the same thing in grey itself.

At first it seemed to mean slowly forcing color from the paintings. There were a few grey paintings with other colors, frank blue or yellow or green. Then there were those in which I pushed against the color or into the color with grey, using burnt umber, raw umber or black. The very last paintings I did in Chester were all grey using only raw umber. Snow clouds, mists, some with a light trying to be felt, some barely suggestive of shadows and the sea.

After I crossed the Atlantic this year, my first trips to the Highlands from Edinburgh were during snow storms. I saw the very paintings I had painted in Chester. These and more. It was like a miracle of anticipation. Of no one's concern but my own, yet magic nevertheless.

In all my recent work, the work done at Romasaig with the reality of the sea and sky beyond the window, the painting has become more and more abstract, more defined, and, in becoming so, has become more real. It's what I had hoped for, but had no idea of how it would happen.

**Romasaig, 15 November 1970**

*The Sound of Sleat: A Painter's Life,* pp. 199–200

**Romasaig, 16 November 1970**

*The Sound of Sleat: A Painter's Life,* p. 202

# The Sound of Sleat: June Night

Last night I had one of the very important visual experiences of my life. It was late, 11:30, when I looked out the studio window and was struck by the somberness of what I was able to see. I went out, then called Raoul [Middleman], and we stayed for over an hour. Standing our small ground at the edge of the sea we seemed isolated from the Sound of Sleat, the Sleat Peninsula and the sky and cloud above it. The vision was intensely real, yet it was the most powerful abstraction – Nature a cold, stately presence, remote and unconcerned, beyond man's definitions, his identifications, his attempts at understanding, oblivious to his emotion. Man could only be irrelevant in the face of this implacable event, this dark and light of eternal death. Everything about the Sound of Sleat that I might have remembered, every color, shape or form, the identity of sky, land or water was destroyed and replaced by those events which I can only call the unearthly light, the dark, dark, rich beyond the black, the mass of grey, and the deep shimmering of a streak below, a presence more powerful, more beautiful, more seductive, more real than man's fantasies of poetry or joy or the damnation of his days.

There now have been three massive experiences I have had with the Scottish sky. The first, in March of 1958 when I had given up and, aching in my head and eyes and soul, I cycled from Mallaig Vaig to the white sands of Arisaig, where I watched the snow clouds moving toward me, implacable, from the sea. One passed over and through me, snow beating against my face. Then I turned to the south and saw the winter sun glowing in the snow cloud; strange image of light burning and dying through the shadows of a changing form. Though the sun was a winter sun, it translated itself in my mind to the most powerful and vibrant colors, reds, yellows, Indian yellows, or sometimes alizarin through blue.

The second experience was in 1967 when I was at sea with Jim Manson, the day of the gale. A mist hung like a curtain to the sea, haunted by a subtle glow from the direction of Rhum. I pointed out the image to Jim, who said, "Yes, we call that a Sun Dog; it's the sign of the gale." This warning of the storm that was to drive us from the sea was the most delicate sign, impossible to draw, impossible to define, impossible to understand except in the most exquisitely sensitive terms.

And now, with Raoul, this vision of death, or of Nature beyond life, or of Nature as she must exist beyond that fantasy of life that we imagine. I wish that I could devote endless days and years to this cold and passionate truth. This noble, dispassionate truth. This frightening truth.

**Romasaig,
June 1970**

*The Sound of Sleat:
A Painter's Life,*
p. 189

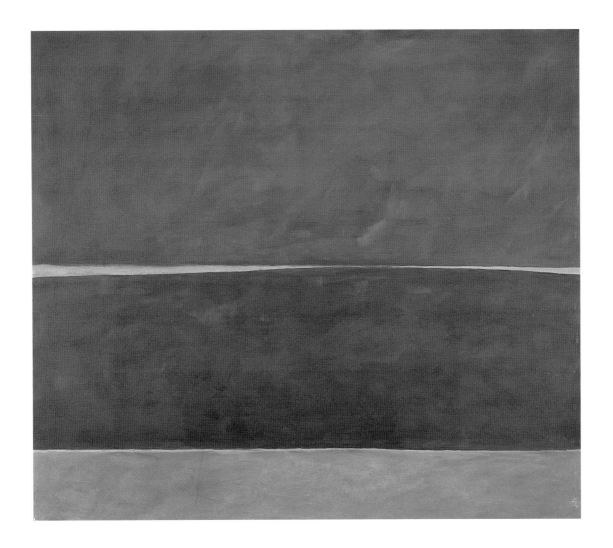

**Pl. 48**
**The Sound of**
**Sleat: June Night**
**XIII**

Romasaig, 1970
Oil on canvas
132 × 152 cm
(52 × 60 in.)
Inv. no. o/c 50

**Pl. 49**
**The Sound of**
**Sleat: Red in**
**a Summer**
**Night VII**

Romasaig, 1970
Oil on canvas
127 × 152 cm
(50 × 60 in.)
Inv. no. o/c 15

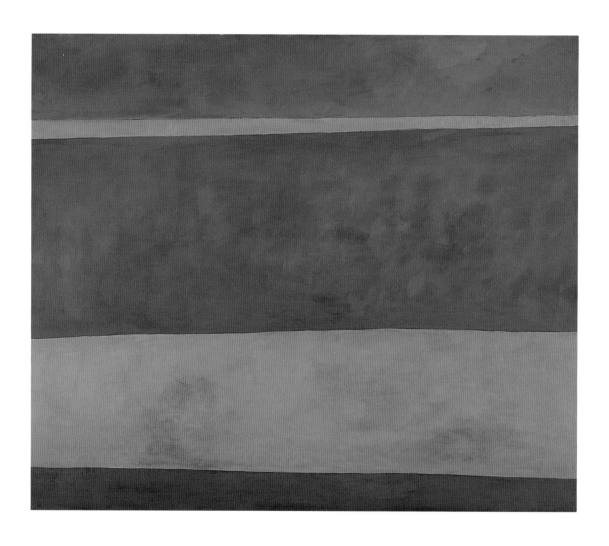

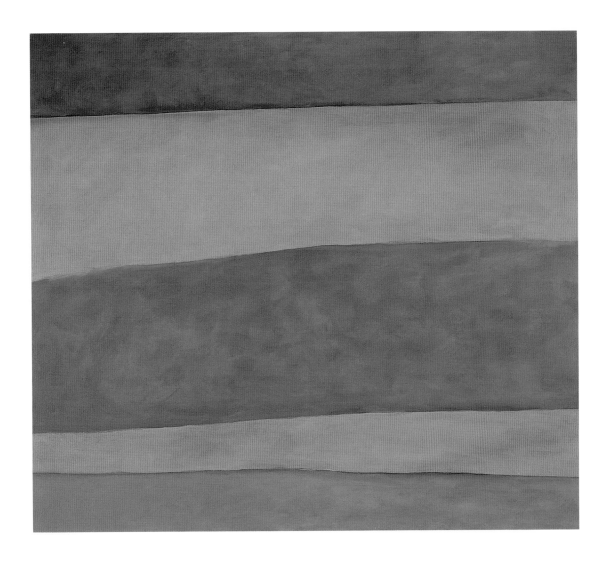

**Pl. 50**
**The Sound of Sleat: Red in a Summer Night VI**

Romasaig, 1970
Oil on canvas
132 × 152 cm
(52 × 60 in.)
Inv. no. o/c 16

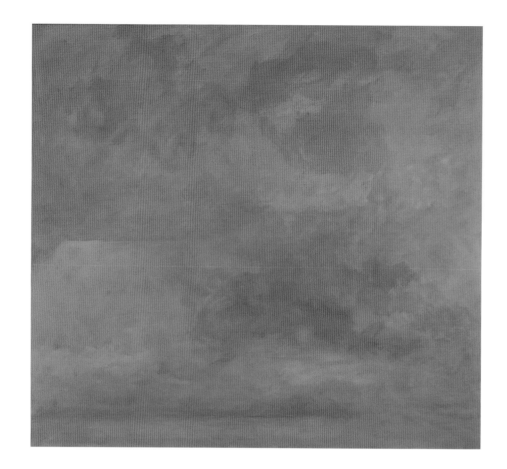

**Pl. 51**
**A Shadow in the**
**Red Sky Moving II**

Romasaig, 1971
Oil on canvas
175 × 193 cm
(69 × 76 in.)
Inv. no. o/c 103

**Pl. 52**
**Mist and the**
**August Sea I**

Romasaig, 1971
Oil on canvas
61 × 71 cm
(24 × 28 in.)
Inv. no. o/c 134

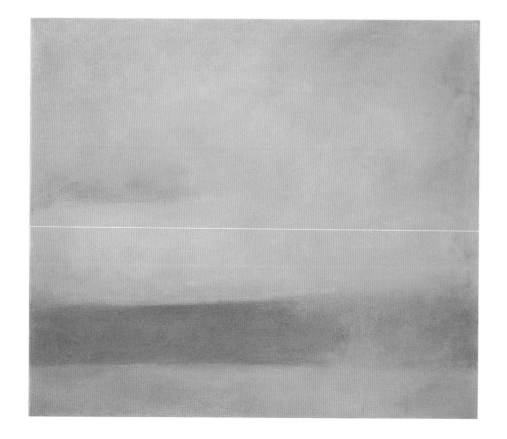

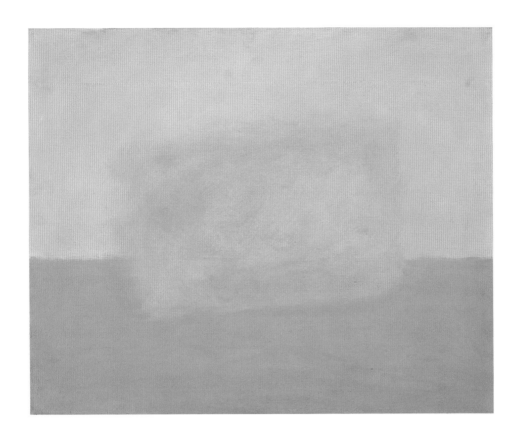

**Pl. 53**
**Fantasy:**
**Light Near Rhum**

Romasaig, 1972
Oil on canvas
61 × 76 cm
(24 × 30 in.)
Inv. no. o/c 209

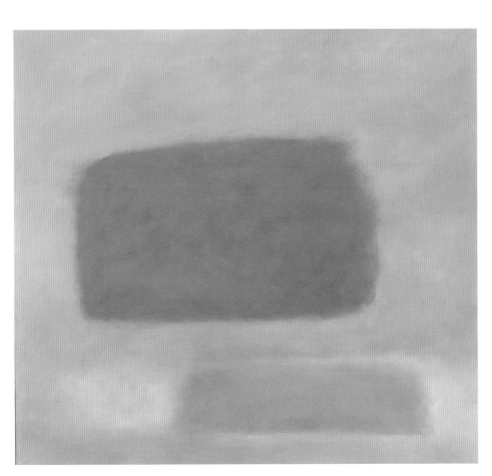

**Pl. 54**
**Reflection:**
**Grey and Gold**

Romasaig, 1972–73
Oil on canvas
175 × 193 cm
(69 × 76 in.)
Inv. no. o/c 355

**Pl. 55**
**Sun and Fog III**

Romasaig, 1973
Oil on canvas
183 × 201 cm
(72 × 79 in.)
Inv. no. o/c 333

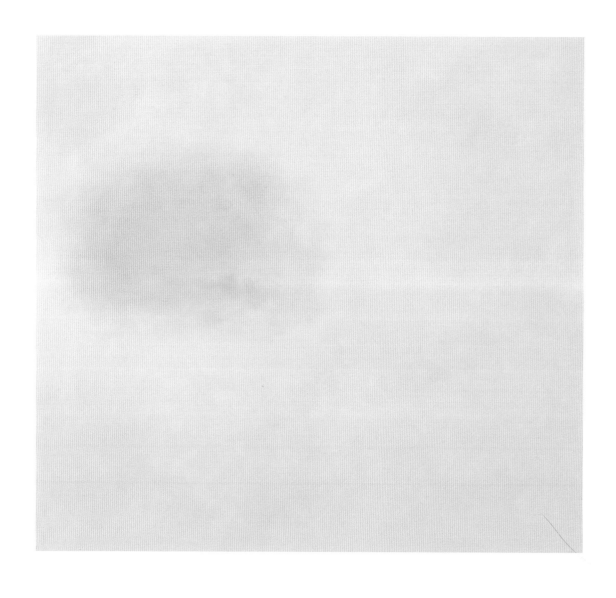

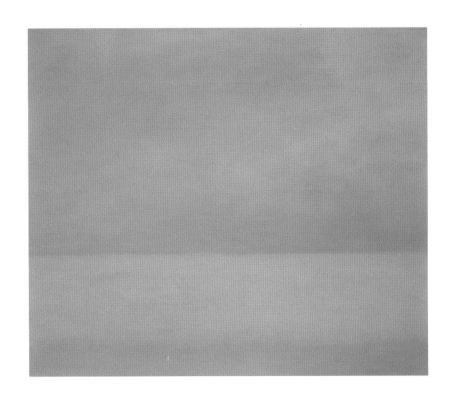

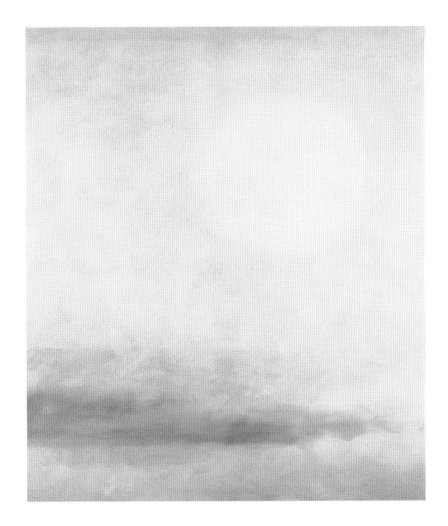

Pl. 56
**Sleat: Winter Blues II**

Romasaig, 1974
Oil on canvas
91 × 112 cm
(36 × 44 in.)
Inv. no. o/c 424

Pl. 57
**Sun**

Romasaig, 1974
Oil on canvas
178 × 160 cm
(70 × 63 in.)
Inv. no. o/c 435

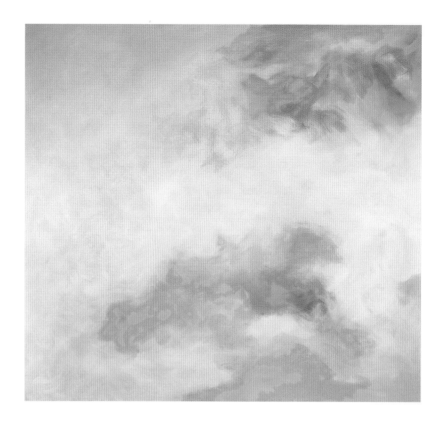

**Pl. 58**
**Storm Near**
**Knoydart**

Romasaig, 1974
Oil on canvas
183 × 201 cm
(72 × 79 in.)
Inv. no. o/c 547

**Pl. 59**
**Night Sun and**
**Sleat Shadow**

Romasaig, 1974
Oil on canvas
193 × 175 cm
(76 × 69 in.)
Inv. no. o/c 561

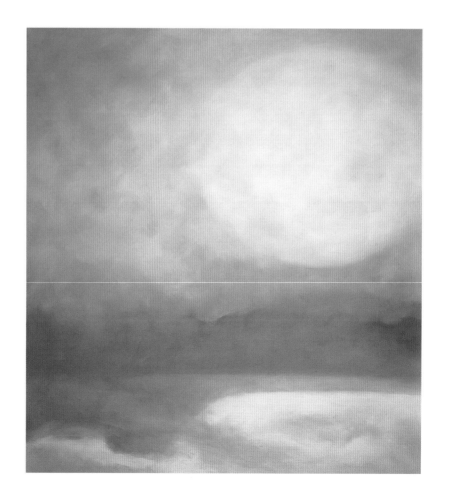

I think of this artist's life, in part, as a rending of veil after veil of self-deception. The romantic never knows whether he is creating the veils out of his fantasy, or is assuming, out of his fantasy, a truth behind the veil. As each dim shadow becomes defined, it can only be questioned as a cover for the next.

To go to sea on the *Margaret Ann* is to sail into my picture. The image is the sea and the sky and always, except when I am before the canvas or in my fantasy, I am standing on land and lifting myself forward into the sensation of sea and sky, of snow cloud and sun. To sail in the *Margaret Ann*, or to anticipate sailing – perhaps it's the imaginary event more than the real one – brings me deep into the painting. The storm takes place, the ship moves under me, the mist marries the sea. From the sea, the sky is even more massive, changing, subtle, incomprehensible, than from land. Yet, the emotions of the voyage itself are far more profoundly real before and after than during the days and nights at sea. Are the strange, deep, boundless emotions of death more or less real than the curiously defined events at sea? The fantasy, before and after, seems powerfully three dimensional. The emotions of the voyage have the two-dimensional quality of work, of action.

During the three-week warm spell of this year's June the haze formed over the Sound of Sleat, more intense each day. One late afternoon I was walking down from Mallaig Vaig looking southwest over the harbor and out to sea. There was no telling where the sea ended and the sky began, it was all a mysterious haze-white, pulsing with the northern summer light. It was late Friday and the boats were coming in and they emerged like formations of aircraft from the white sky.

The idea of the hand. I take responsibility for the hand, for its feelings and its movement. That moment's quiver, that moment's nuance, that caress of paint, that force or failure, that is the hand and is the knowing and the music of the hand.

**Romasaig,
17 November
1970**

*The Sound of Sleat:
A Painter's Life,*
p. 203

**Romasaig,
24 November
1970**

*The Sound of Sleat:
A Painter's Life,*
p. 210

**Romasaig,
19 November
1970**

*The Sound of Sleat:
A Painter's Life,*
p. 204

**Romasaig,
16 November
1970**

*The Sound of Sleat:
A Painter's Life,*
p. 202

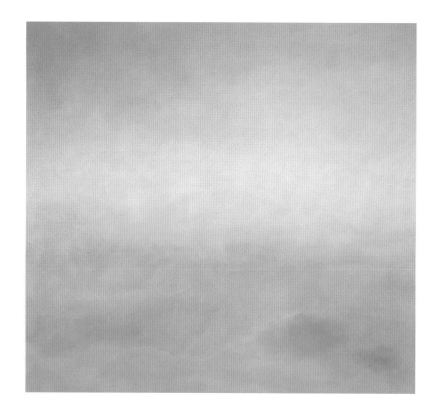

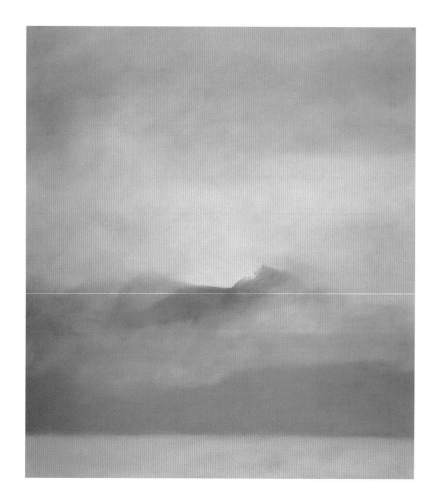

98

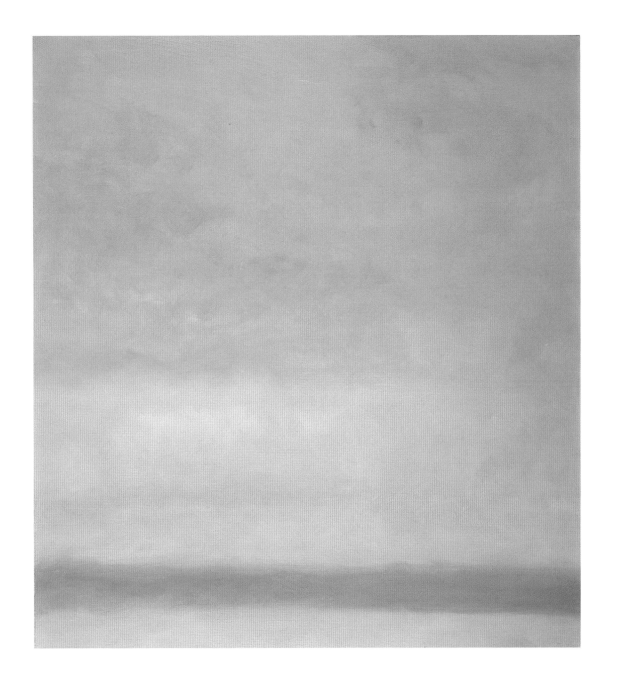

**Pl. 62**
**Summer Red**
**Blues**

Romasaig, 1975–77
Oil on canvas
122 × 112 cm
(48 × 44 in.)
Inv. no. o/c 618

**Pl. 63
Mood with
Magda: Love
Remembered II**

New York, 1975
Oil on canvas
183 × 165 cm
(72 × 65 in.)
Inv. no. o/c 637

**Pl. 64
Death of the
Father**

New York, 1976
Oil on canvas
183 × 540 cm
(72 × 216 in.)
Inv. no. o/c 791

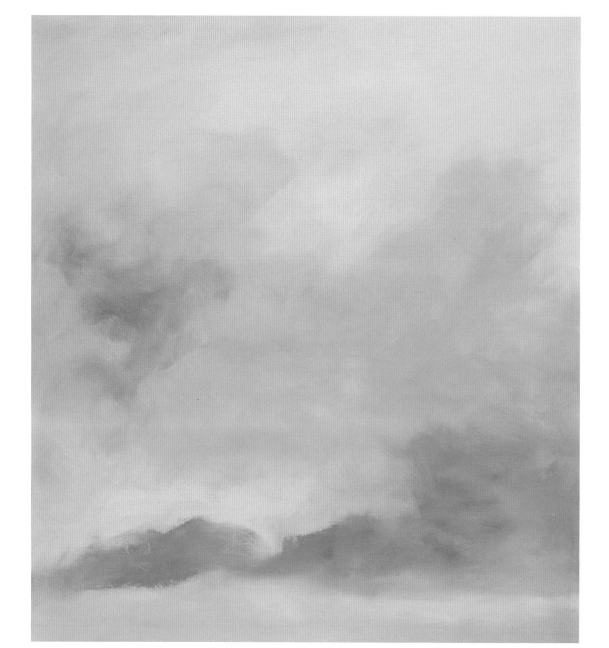

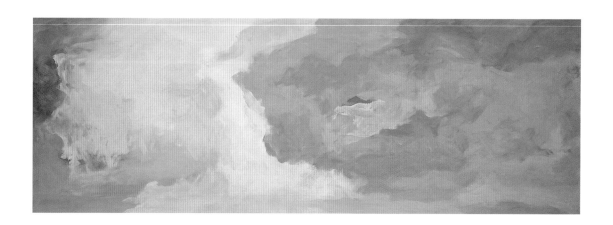

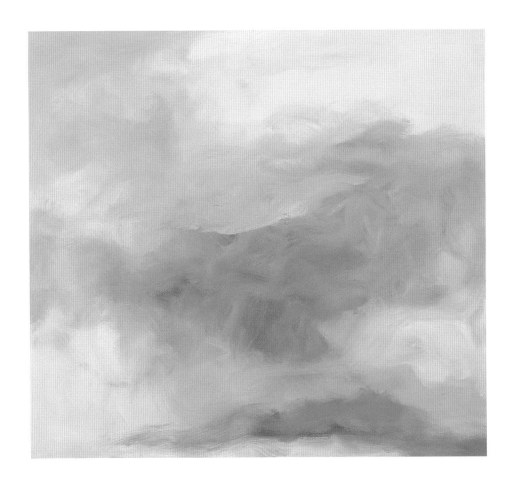

**Pl. 65**
**Night Offering**

New York, 1976
Oil on canvas
137 × 152
(54 × 60 in.)
Inv. no. o/c 805A

**Pl. 66**
**Evening Blues**

New York, 1976
Oil on canvas
102 × 122 cm
(40 × 48 in.)
Inv. no. o/c 826

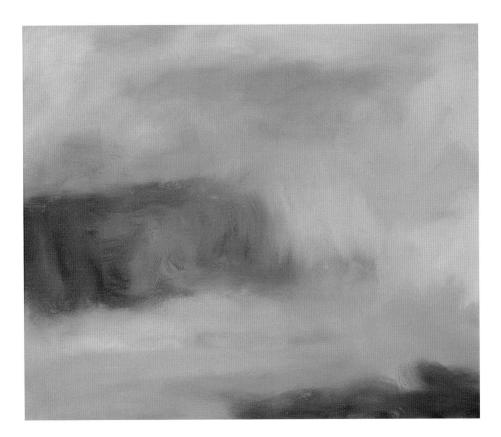

**Pl. 67**
**Light and Black**
**Shadow**

Romasaig, 1977
Oil on canvas
175 × 193 cm
(69 × 76 in.)
Inv. no. o/c 876

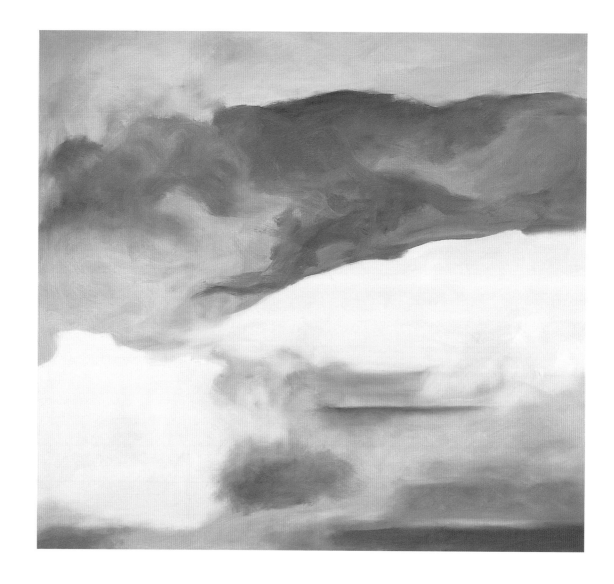

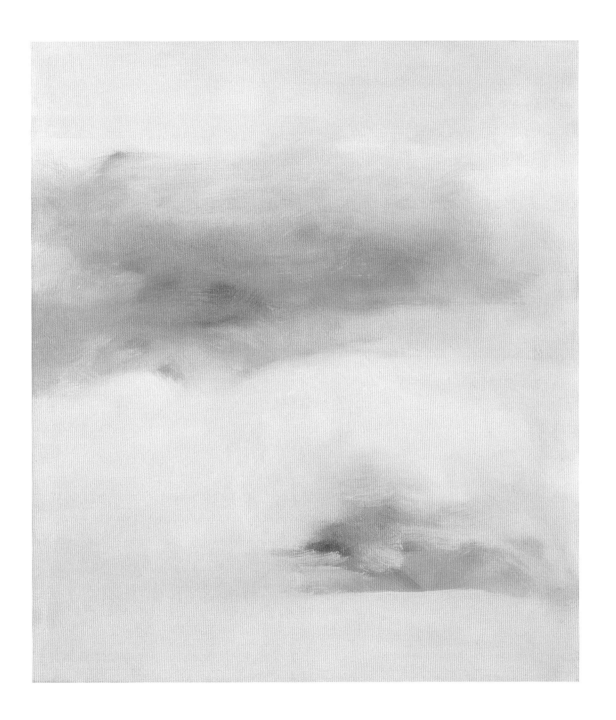

**Pl. 68**
**Greys: Echo II**

New York, 1978
Oil on canvas
91 × 81 cm
(36 × 32 in.)
Inv. no. o/c 933

**Pl. 69**
**w/c 398**

New York, 1978
Watercolour
17 × 25 cm
(6 ½ × 10 in.)
Inv. no. w/c 398

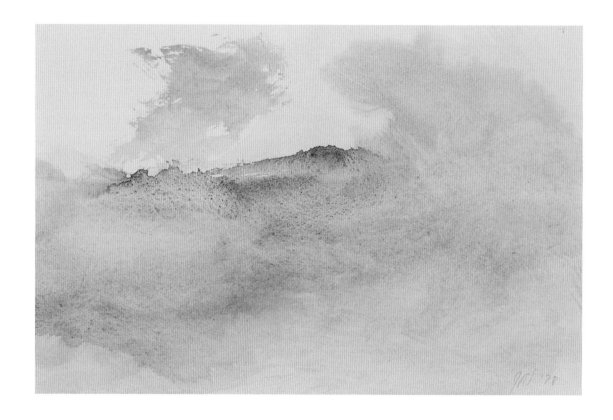

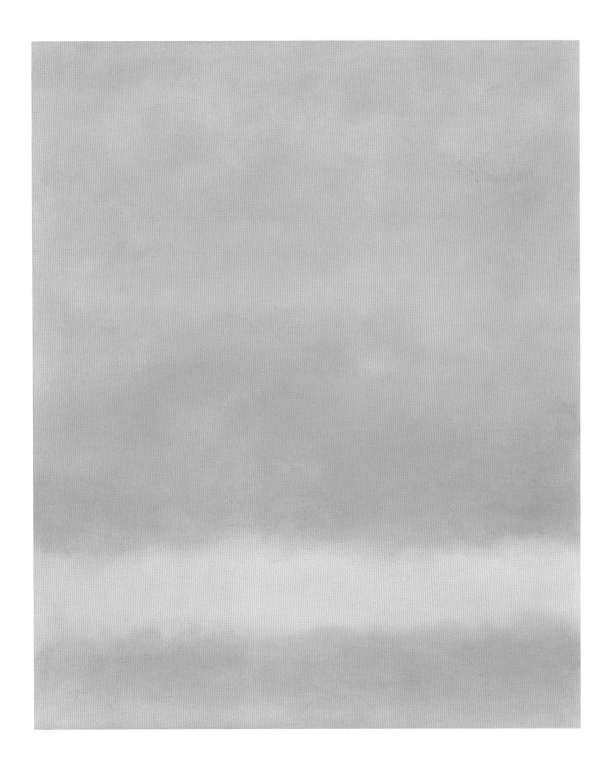

**Pl. 70**
**Remember**

New York, 1979
Oil on canvas
91 × 76 cm
(36 × 30 in.)
Inv. no. o/c 973

**Pl. 71**
**Weathering I**

New York, 1980
Oil on canvas
201 × 420 cm
(79 × 168 in.)
Inv. no. o/c 1097

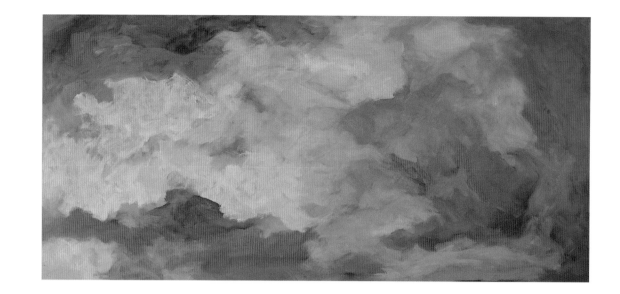

**Pl. 72**
**Forgotten Blues II**

New York, 1981
Oil on canvas
183 × 305 cm
(72 × 120 in.)
Inv. no. o/c 1131

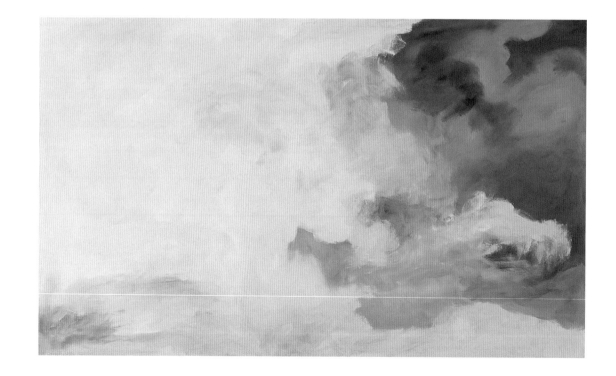

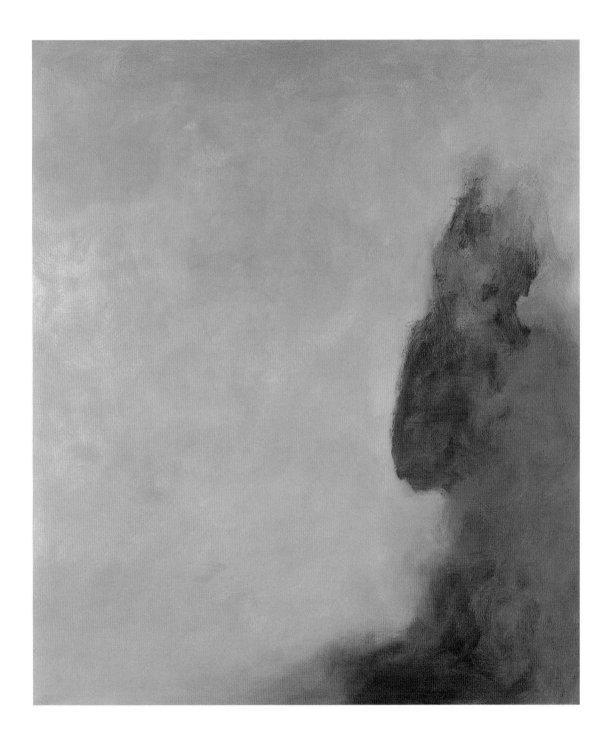

**Pl. 73**
**The Search: Black Shadow Blues IV**

Romasaig, 1981
Oil on canvas
152 × 132 cm
(60 × 52 in.)
Inv. no. o/c 1155

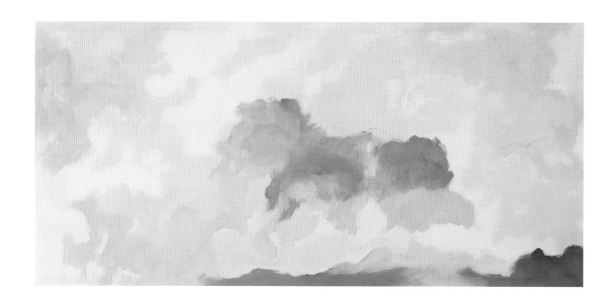

**Pl. 74**
**The Search I**

Edinburgh, 1981
Oil on canvas
201 × 427 cm
(79 × 168 in.)
Inv. no. o/c 1178

**Pl. 75**
**The Search V**

Edinburgh, 1981
Oil on canvas
201 × 540 cm
(79 × 216 in.)
Inv. no. o/c 1182

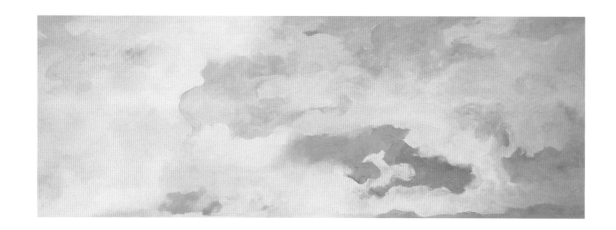

**Pl. 76**
**w/c 497**

Romasaig, 1981
Watercolour
17 × 27 cm
(6⅝ × 10⅜ in.)
Inv. no. w/c 497

It would seem, wouldn't it, that the Mallaig story is about women, or Woman. And my loneliness is because of woman, and my search is because of woman, and my failure exists in woman, and when I peer deep into the horizon of the sky and when the canvas forms and finds its heat and its mystery, it is the uncontrollable mystery of woman and of creation, of formlessness forming, of the un-understandable being felt, suspected, in part known – though never not being unknown. Mother died. Has there ever been a man whose mother has not died? Or whose father has not lived? Mine died – my mother, that is – when I was six months old. It's the total horror of everything becoming nothing, yet continuing to demand an existence. It's warmth and no sustenance. It's the strange and painful gift of life and the condemnation to an endless search for life, but only through the search for the giver of life. As though the life that has been given doesn't exist because the giver is gone, as though it can be found only if the giver is found or absorbed or understood.

**East Hampton NY, 29 August 1961**

*The Sound of Sleat: A Painter's Life,* pp. 118–19

One other note – this about communication. Another bewildering area for the contemporary artist – at least for me. The need is intense, total, absolute. Again, I can scarcely believe in the act of what I am doing unless I can imagine and foresee the communication that will take place. Yet, the painting, which has been formed as a result of the most intimate activity, and presumably holds in its structure the most intense feelings, the most personal visions – when it goes from the studio, this painting seems to land immediately, in this day and age, in the most commercial of commercial enterprises. For the moment, the artist is blinded by the galleries, the museums, the success talk of artists (all of us acting vain, ambitious, with a braggadocio that would have been bad taste in the tire business), the curious needs of the collectors (if you will, for my point to be made). He started – somewhere, at some moment – with love. He ended with money. Or he didn't end with money – which is worse. He can no longer imagine the person whom the painting will reach. Where is that soul whose imagination will be fired, whose vision will be enriched, who will respond to a poetry wrenched from pain? The artist sees dealers haggling and manipulating, art historians playing their passionless games, intellectuals light-footedly pirouetting over each others' thin-iced minds, hoi polloi tittering in the museums, collectors – well, collecting! And other artists eternally picking everything to pieces. Who receives? When does the communication take place?

For some reason, as a result of this exchange of letters (and a few days after I received your last letter), the answer came to me very clearly – really for the first time in my life. They all receive – all those human souls, huckstering, or criticizing, or envying, or hoarding, or whatever human souls do. The intimate experiences of life take place in the drama of life, and the painting will have to take its place there, too.

**Guilford CT, 30 March 1961**

**Letter to Ben Heller**

*The Sound of Sleat: A Painter's Life,* pp. 111–12

**Pl. 77**
**Goodbye Blues**
**for Bunty**

Edinburgh, 1981
Oil on canvas
201 × 183 cm
(79 × 72 in.)
Inv. no. o/c 1185

Detail opposite

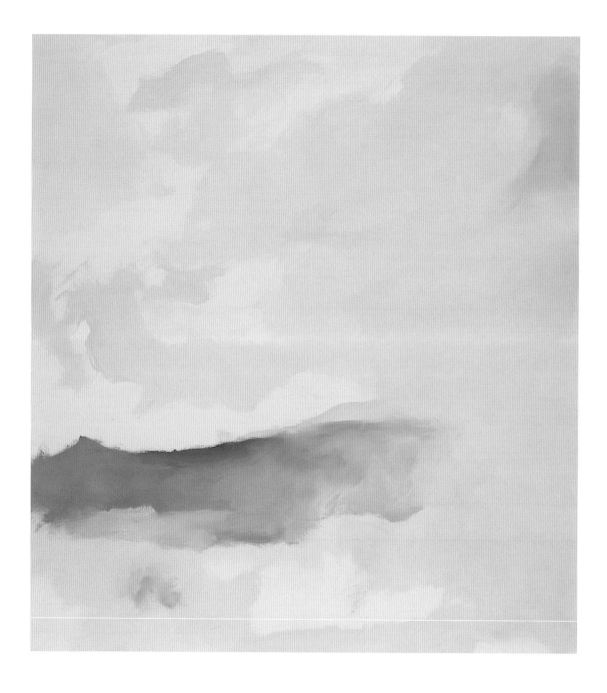

110

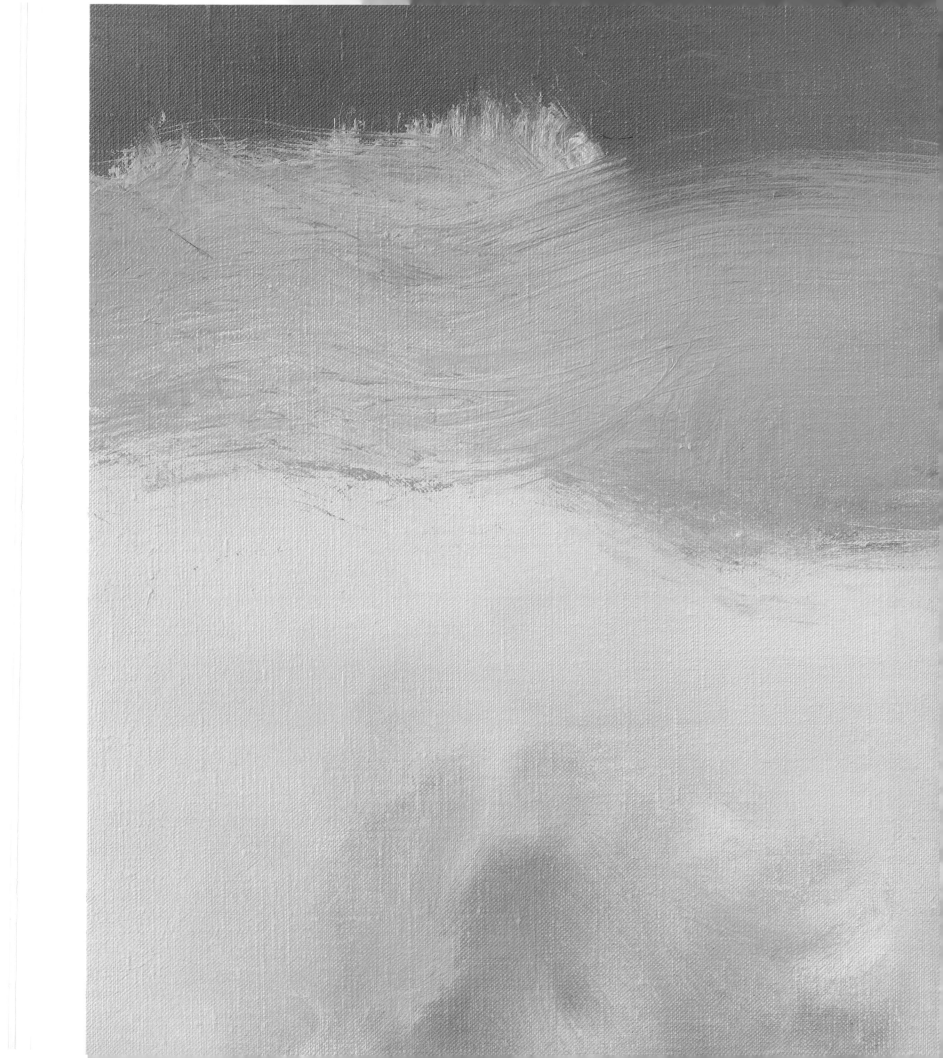

**Pl. 88**
**Red Shadow in
my Sleep**

New York, 1990
Oil on canvas
107 × 165 cm
(42 × 65 in.)
Inv. no. o/c 1660

Detail opposite

B

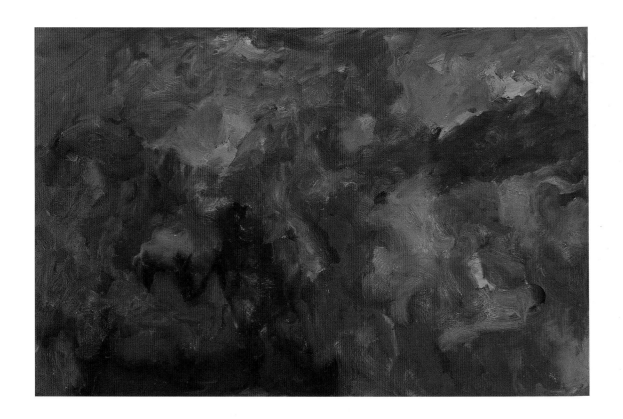

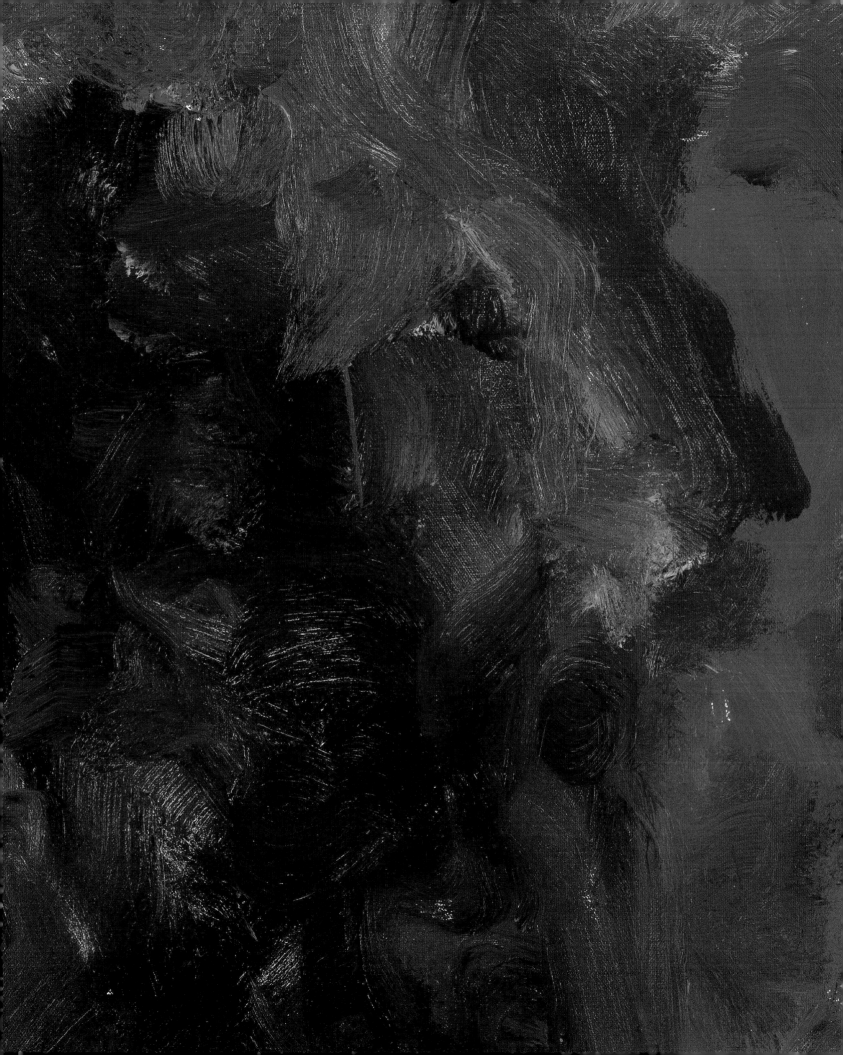

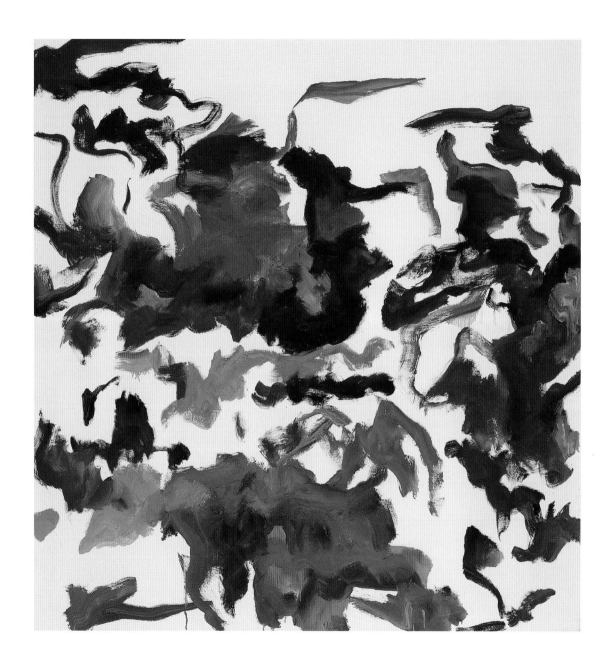

**Pl. 89
Pending
Possibilities IV**

New York, 1990
Oil on canvas
185 × 178 cm
(73 × 70 in.)
Inv. no. o/c 1685

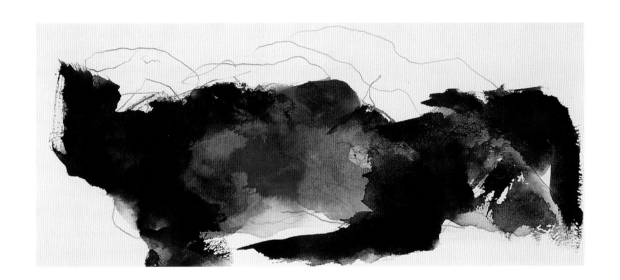

**Pl. 90**
**w/c 852**

Romasaig, 1991
Watercolour and
pencil
15 × 36 cm
(6 × 14 in.)
Inv. no. w/c 852

1963/64/65/66
*Artists for CORE* (Congress of Racial
Equality), held at various galleries in
New York

1973
*A Period of Exploration: San
Francisco 1945–1950*, Oakland
Museum of California, Oakland

1975
*Landscapes, Interior and Exterior:
Avery, Rothko, and Schueler*, The
Cleveland Museum of Art,
Cleveland OH

1984
*Creation: Modern Art and Nature*,
Scottish National Gallery of
Modern Art, Edinburgh

1988
*The Impact of Scotland on Two
American Artists: Jon Schueler and
Daniel Lang*, William Hardie Ltd at
the Edinburgh College of Art

1994
*Land, Sea and Air: Nanno de Groot,
Elaine Kurtz, Jon Schueler*, Anita
Shapolsky Gallery, New York

1996–97
*El Expresionismo Abstracto y La
Experienca Estadounidense*, Centro
Cultural/Arte Contemporaneo,
Mexico City

1997
*Artists of the 1950s*, Anita Shapolsky
Gallery, New York

## Selected Solo Exhibitions

1950
Metart Gallery, San Francisco

1954/61/63
Stable Gallery, New York

1957/59
Leo Castelli, New York

1960
Hirschl & Adler Galleries, Inc.,
New York

1967
The Maryland Institute, Baltimore

1971
Richard Demarco Gallery,
Edinburgh

1973
Arranged by Richard Nathanson at
the Edinburgh College of Art,
Edinburgh

1974
Lester Gallery, Inverness CA

1975
Dayton's Gallery 12, Minneapolis

1975
Whitney Museum of American Art,
New York

1977
Landmark Gallery, New York

1978
House (gallery), London

1980
John C. Stoller & Co., Minneapolis

1981
Squibb Gallery, Princeton NJ

1981/84
Dorothy Rosenthal Gallery, Chicago

1981
The Talbot Rice Art Centre,
University of Edinburgh, Edinburgh

1982/86/91
Dorry Gates Gallery, Kansas City
MO

1983/84
AM Sachs Gallery, New York

1984
William Sawyer Gallery, San
Francisco

1986/87/89/91/99/2002
Katharina Rich Perlow Gallery, New
York

1991/94
The Scottish Gallery, Edinburgh

1995/96/99/2002
ACA Galleries, New York

1999–2001
Sweet Briar College, Sweet Briar VA,
and touring (retrospective)

2000/02
Ingleby Gallery, Edinburgh

# Bibliography

## Selected Public Collections

City Art Centre, Edinburgh, Scotland

The Cleveland Museum of Art, Cleveland OH

Colby College, Museum of Art, Waterville ME

The Detroit Institute of Arts, Detroit

Glasgow Museums: Art Gallery and Museum, Kelvingrove, Glasgow, Scotland

Frederick Weisman Art Museum, Minneapolis

The Greenville County Museum of Art, Greenville SC

Harwood Museum of Art, Taos NM

Kirkcaldy Museum and Art Gallery, Kirkcaldy, Scotland

Mallaig Heritage Centre, Mallaig, Scotland

Minneapolis Institute of Arts, Minneapolis

Roy Neuberger Museum, Purchase NY

National Academy of Design, New York

Scottish National Gallery of Modern Art, Edinburgh, Scotland

Union College, Schenectady NY

University of Pennsylvania, Philadelphia

University of Stirling, Stirling, Scotland

West Highland Museum, Fort William, Scotland

Whitney Museum of American Art, New York

Yale University Art Gallery, New Haven CT

Gerald Astor, *The Mighty Eighth: The Air War in Europe as Told by the Men who Fought It*, New York 1997. Draws extensively on Schueler's writings of his war experience.

Whitney Balliett, 'Profiles: City Voices: Jon Schueler and Magda Salvesen', in *The New Yorker*, 25 February 1985

John I.H. Baur, *Nature in Abstraction: The Relation of Abstract Painting and Sculpture to Nature in Twentieth-Century American Art*, exhib. cat., New York, Whitney Museum of American Art, 1958

B.H. Friedman, *Jon Schueler in the Fifties: The Seeds of 'Nature in Abstraction'*, exhib. cat., New York, ACA Galleries, 1996, pp. 3–10

Edward Henning, *Landscapes, Interior and Exterior: Avery, Rothko, and Schueler*, exhib. cat., Cleveland OH, Cleveland Museum of Art, 1975

Susan Landauer, *The San Francisco School of Abstract Expressionism*, Berkeley CA 1996

Mary Fuller McChesney, *A Period of Exploration: San Francisco 1945–1950*, exhib. cat., Oakland, Oakland Museum of California, 1973

Diane Moran, 'About the Sky', in *Jon Schueler: About the Sky*, exhib. cat., ed. Rebecca Massie Lane, Sweet Briar VA, Sweet Briar College, 1999, pp. 3–26

'Old Master's Modern Heirs', Monet: Jon Schueler, Sue Mitchell, Hyde Solomon, Sam Francis, Jean-Paul Riopelle, *Life*, 2 December 1957

*Orion: People and Nature*, summer 2001, pp. 46–57

Alastair Reid, 'Jon Schueler', in *School of New York: Some Younger Artists*, ed. B.H. Friedman, New York and London 1959, pp. 66–71

Irving Sandler, *Abstract Expressionism and the American Experience*, exhib. cat., Mexico, Mexico City, Centro Cultural/Arte Contemporaneo, 1996–97

Irving Sandler, *The New York School: The Painters and Sculptors of the Fifties*, New York 1978

Jon Schueler, *The Sound of Sleat: A Painter's Life*, ed. Magda Salvesen and Diane Cousineau, intro. Russell Banks, New York 1999

Jon Schueler, 'A Letter about the Sky', *It is*, no. 5, spring 1960, pp. 12–14.

Jon Schueler, *a statement by the artist: jon schueler*, exhib. brochure, New York, Stable Gallery, 1954

*Jon Schueler: Paintings 1964–75: Paintings 1976–83*, exhib. cat., ed. Magda Salvesen, New York, ACA Galleries and Katharina Rich Perlow Gallery, 1999

*Terra Nova*, vol. 1, no. 4, spring 1996, pp. 98–111

## Films and videos

*Jon Schueler: A Life in Painting*, L&S Video, Inc., 1999, directed by Magda Salvesen

*Jon Schueler: An Artist and his Vision*, Films of Scotland, 1972, directed by John Black

*Jon Schueler Painting*, University of Edinburgh, Audio Visual Production Services, 1981, directed by Jim Sheach

# Picture Credits and Acknowledgements

All Jon Schueler paintings and drawings reproduced in this book belong to the Jon Schueler Estate unless otherwise noted.

## Figs

Fig. 6: Photographer: Mrs. Jack Lowe

Fig. 7: Hirshhorn Museum and Sculpture Garden, Smithsonian Institition, Washington, D.C., Joseph H. Hirshhorn Purchase Fund, 1992. Photographer: Lee Stalsworth

Fig. 8: The Frances Lehman Loeb Art Center, Vassar College, Poughkeepsie, New York. Gift of Mrs John D. Rockefeller 3rd (Blanchette Hooker, class of 1931) 1955.6.6. © 2002 Kate Rothko Prizel and Christopher Rothko/Artists Rights Society (ARS), New York

Fig. 9: Museum of New Mexico, Museum of Fine Arts, Gift of Mr and Mrs Gifford Phillips, 1980. Photographer: Blair Clark

Fig. 10: The Metropolitan Museum of Art, New York, George A. Hearn Fund, 1956 (56.205.1). Photograph © 1986 The Metropolitan Museum of Art

Fig. 11: Photographer: Oliver Baker

Fig. 12: Photograph courtesy of Anita Shapolsky Gallery, New York

Figs. 13, 14, 19, 20, 22: Photographer: Oote Boe

Figs. 15, 16, 26, 27, 28, 29, 30, 40: Photographer: Jon Schueler

Fig. 21: Photographer: Robert Bernhard

Figs. 32, 33: Tate Britain. © Tate, London, 2001

Fig. 34: Photograph: Courtesy of PaceWildenstein, New York. © 2002 Kate Rothko Prizel and Christopher Rothko/Artists Rights Society (ARS), New York

Figs. 31, 35, 36, 42: Photographer: Magda Salvesen

Fig. 37: Photographer: Geoffrey Clements for the Whitney Museum of American Art, New York

Fig. 38: Photograph: Cleveland Museum of Art, Cleveland OH

Fig. 39: Photographer: Dudley Gray

Figs. 41, 43: Photographer: Archie I. McLellan

Fig. 44: Photographer: Sarah Wells

## Plates

Pl. 2: Ernest A. Bates, Napa, California

Pl. 12: The Detroit Institute of Arts, Gift of Ms Rosemary Franck. Photograph © 1998 The Detroit Institute of Arts

Pl. 14: Darwin and Geri Reedy, Minnesota

Pl. 15: John and Anne Codey, New York

Pl. 21: Whitney Museum of American Art, New York; purchase, with funds from the Friends of the Whitney Museum of American Art 58.37

Pl. 24: Darwin and Geri Reedy, Minnesota

Pl. 27: The Family of Ben Heller, New York

Pl. 36: Myles and Liana Thompson, New York

Pls. 46, 48, 49, 50, 56, 58, 59, 60, 61, 62, 67: Photographer: John McKenzie

Pl. 57: Private Collection, Scotland. Photographer: John McKenzie

Pl. 66: Private Collection, California

Pl. 73: Glasgow Museums: Art Gallery and Museum, Kelvingrove, Glasgow

All colour photography not mentioned above was supplied by the Jon Schueler Estate. Photographer: Oote Boe, New York, with thanks for his care and skill. © Jon Schueler Estate. All black-and-white photographs other than figs. 37 and 38 were supplied by the Jon Schueler Estate. © Jon Schueler Estate.